A M E R I C A N
GOTHIC

AMERICAN GOTHIC

The Biography of Grant Wood's American Masterpiece

THOMAS HOVING

Chamberlain Bros.
a member of
Penguin Group (USA) Inc.
New York
2005

CHAMBERLAIN BROS.
Published by the Penguin Group
Penguin Group (USA) Inc., 375 Hudson Street, New York, New York 10014, USA
Penguin Group (Canada), 90 Eglinton Avenue East, Suite 700, Toronto, Ontario
M4P 2Y3, Canada
(a division of Pearson Penguin Canada Inc.)
Penguin Books Ltd, 80 Strand, London WC2R 0RL, England
Penguin Ireland, 25 St Stephen's Green, Dublin 2, Ireland (a division of Penguin
Books Ltd)
Penguin Group (Australia), 250 Camberwell Road, Camberwell, Victoria 3124,
Australia (a division of Pearson Australia Group Pty Ltd)
Penguin Books India Pvt Ltd, 11 Community Centre, Panchsheel Park,
New Delhi–110 017, India
Penguin Group (NZ), Cnr Airborne and Rosedale Roads, Albany, Auckland 1310,
New Zealand (a division of Pearson New Zealand Ltd)
Penguin Books (South Africa) (Pty) Ltd, 24 Sturdee Avenue, Rosebank,
Johannesburg 2196, South Africa

Penguin Books Ltd, Registered Offices: 80 Strand, London WC2R 0RL, England

Chamberlain Bros.
a member of Penguin Group (USA) Inc.
375 Hudson Street
New York, NY 10014

"The Background Story of American Gothic Arts," by Jerry Schwartz.
Copyright © 2001 by Jerry Schwartz

An application has been submitted to register this book with the Library of Congress.

ISBN 1-59609-148-7

Printed in the United States of America
10 9 8 7 6 5 4 3 2 1

Book design by Michael Rivilis

CONTENTS

1.

AMERICAN GOTHIC

Turn to the following spread, pages 2 and 3, and on page 2 write down what comes to mind in the first thousandth of a second, the blink of an eye, when looking at the illustration of *American Gothic* opposite. Sure, you've seen it before, but try to look at it as if you never have.

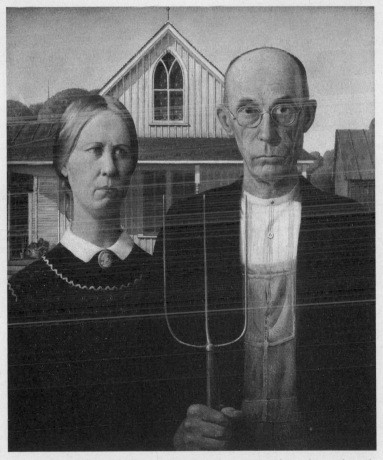

Fig. 1. *American Gothic*, Grant Wood, 1930, oil on beaverboard, $30^{11}/_{16} \times 25^{11}/_{16}$ inches. Friends of American Art Collection. The Art Institute of Chicago. (Photograph copyright © by The Art Institute of Chicago.)

You probably wrote only a word or two, or maybe a phrase, and what you wrote may be somewhat garbled and may not make too much sense. Not to worry. This is not a dissertation. It'll work out eventually, for at the end of the onion peeling you'll want to come back to this first impression.

2.

HAPPY BIRTHDAY

Did you write "Happy Birthday"? You should have. Grant Wood's *American Gothic* is seventy-five years old in July 2005. When it was first exhibited in Chicago in 1930 at an annual painting and sculpture show, few of those who gazed at it— somewhat in awe, for it was very different from anything else in the vernissage—would have believed that it would stick that long in the public consciousness. Today, it seems that more people know of *American Gothic* and have more opinions about it than any time in its history—it's become a sort of Rorschach test for the character of the nation, both good and bad. Ironically, this painting is more famous worldwide than many of the treasures of New York's estimable Museum of Modern Art, itself seventy-five years old in 2004.

American Gothic has been lavishly praised, brutally condemned, waved aloft as a symbol of the greatest good of our land, its creator hailed as American art's Columbus, put down as an inept copy of an Old Master, viciously attacked (politically, thankfully, not physically), vilified, psychoanalyzed, mocked, accused of being the Devil's work, its maker called a virtual Nazi sympathizer, snickered at, called a corpse, caricatured, used for myriad parodies, and held hostage for any number of advertisements and Halloween costumes. Since it's been in the public eye, its significance has been puzzled over more than any other painting in American history, and it has become the preeminent American art icon.

Why *American Gothic*? What's it got going for it? Is it a serious work of art or just a hyped cliché? Or just handy scaffolding for the jokes of lesser artists? Is it, in fact, any good?

To find out, let's subject the painting to a connoisseur's scrutiny and peel the onion apart to get to its very heart. To do so, I'll follow a checklist that I've used for years, so as not to miss anything. See The Checklist, page 127.

That blink-of-the-eye impression is first on the checklist. What will it get you?

Many art connoisseurs believe that the first words that tumble to mind when seeing a work for the first time are vital. They think that these words clue you in to the inner secrets of a work that even intense scrutiny and months-long historical, technical, and scientific examination will not reveal more clearly. I agree.

The key to approaching a work of art—any work or art, it doesn't matter if it's an ancient Egyptian sculpture, the *Mona Lisa*, or what seems at first to be a super-postmodern, incomprehensible, and therefore threatening work—is to keep an open mind. Go to it with optimism. Never pay heed to what others have said about it in the past or are even saying alongside you in the present. I think of art as a person you're just about to meet who might change your life—possibly for the better.[1]

We're going to look at *American Gothic* a bit differently than an art critic or an art historian would. As connoisseurs (from the French, "knowers"), we're going to be primarily—even obsessively—interested in the simple reality of the work itself and how good or bad it is. Of lesser interest is the history surrounding it and supposedly learned interpretations of it. The connoisseur focuses on just the unalloyed work, and thinks this: every estimable work of art should be able to be understood on its own visual merits without any further explanation, interpretation, or yakking. If a work needs a three-foot-high label in small type to explain it, it is probably not much good. Indeed, if a work needs a title like *American Gothic* to be understood, it might not be any good, either. If Grant Wood hadn't given it a title, would you get it? I am positive you would.

Every work of art should be a powerful visual statement, an eloquent speech without words, a symphony of visual notes and movements. You don't really have to know the many details about the story of David and Goliath to know that Michelangelo's young,

well-muscled teenager holding a sling is about to get into some fracas and he's somewhat hesitant about it. And you don't even have to know that this is the biblical David to be utterly overwhelmed by his beauty. And it's enough to know that the work dates to around 1500. Although it can be a pleasure to stuff your mind with the lengthy history of the High Renaissance, you don't need to to love this statue. The breathtakingly powerful image stands on its own.

Even something as subjectless as a Jackson Pollock stands on its own. To get a tremendous bang out of, say, *Autumn Rhythm*, of 1950, at the Met and admire the gigantic, complicated thrums of black and rust-colored paint ignited by silvery splatters, swishing around with unbounded energy, you don't need to know a thing about the birth of the New York School or the daily ins and outs of the development of abstract expressionism. To appreciate its energy and action, you don't need the ministrations of a bunch of art critics or art historians informing you that the painter is a talentless "Jack the Dripper," or a "genius of perceived movement in a stasis of painterly values," or even a "my kid could do this."

To me, critics have one vital role in the art process: they get the word out. They are like an expanded listing, and are key in letting you know what's going on and where.

What other service art critics perform, I'm not sure. They are too subjective and opinionated for my liking. Too many times I have read what they had written fifty years before and I have to laugh at how off base they were.

These days, art critics—and I know of only two on the planet who are consistently illuminating—seem to

race around a well-beaten path, seeking out miniscule trends and tendencies, writing less for the public than for one another. In fact, they're jockeys on a carousel who think they're really on a racetrack.

Almost all of them have a common failing: they think one style of art is better than another. It's modernism over traditionalism; cubism over realism. (They actually believe in the multitudinous "isms," which clutter up and obscure art history.) Of course, it's nonsense to rank one style over another. That's like calling Spanish a better language than Italian. Gimme a break!

Another reason why I distrust critics is that they hardly ever talk to artists or take seriously what artists say about their work. I remember how puzzled and disdainful I was when the chief art critic of the *New York Times*, John Canaday, boasted to me back in the sixties that he had made it a point of honor never to converse with an artist, at least about works of art. To me and most connoisseurs, the artist's word is gospel.

Critics carry prejudices like the medals and braid on a high-ranking general. Worst of all, they never really look hard at a work of art and scrutinize its every millimeter. You'll never catch them going through the connoisseur's checklist (which, I suspect, they have no idea exists).

But, as I said, they have their role, getting the word out. In the case of Grant Wood's *American Gothic*, they sure did—both right and wrong, as we shall see.

The point is, to be a connoisseur you don't need an advanced degree in art history or archaeology, either, and you don't need to weigh yourself down with the often-convoluted theories of art historians. As we used

to say in graduate school, *"kunstgeschichte ist horsegeschichte."* That's bowdlerized German, meaning "art history is horse _ _ _ t." It's perhaps a bit harsh, yet the ivory-tower overanalysis of every fragment of style, iconography, and iconology does get a bit tedious.

Art historians are vital to understanding a work of art, for they root out original sources and documents and try to discover what influenced a given artist and how his style came to be. Unlike critics, art historians are fact finders, unbiased and objective. They weigh the validity of every fragment of documentation, and seldom come to any conclusions until they have sifted through every bit of it. Without art historians, this book would never have been written.

But art historians also have a downside. I ought to know, having been one for a few years between receiving my graduate degree and the moment I converted to pure connoisseurship when I signed on to a museum. Art historians have been known to stop looking at art while they go off spinning theories about art. (We connoisseurs can do the opposite: we look too much and we read too little.) Historians can go overboard theorizing about what influenced the artist they're studying.[2] In their zeal to figure out what may have influenced an artist, art historians have been known to assume that an artist had to have been influenced by a specific work or by work in a specific exhibition when, in fact, the artist in question was, say, six years old at the time.[3] So when an art historian affirms that Grant Wood was influenced by a particular Hans Memling in Munich or Albrecht Dürer in Nuremberg,

one has to establish that Wood went to these cities and saw their paintings. And just because a figure or two in the *Grande Jatte* by Georges Seurat looks like one or two of Grant Wood's figures, it doesn't mean that he was heavily influenced by the pointillist.

Don't expect a quality judgment from an art historian; they almost never tell us what is good, better, or best in an artist's career. Connoisseurs do. Art historians seem to think that all works are equal in aesthetic stature. They tend to look at art rather more as specimens than examples of creative acts meant to move the viewers' passions, some finer and more successfully than others.

Finally, art historical jargon can get awfully thick at times. All those "isms" and categories that never really existed, like impressionism and postimpressionism, or whatever.[4] Connoisseurs prefer to categorize works as, say, Flemish mid-fifteenth century, or French Academy late nineteenth century, or just by artist's name alone—when I hear "Degas 1884," I know precisely what that style is, and I don't need to hear that he was an impressionist, which, indeed, he never was.

But, hey, art historians are grandly and professionally superior to art critics. They're right up there with us connoisseurs—just kidding.

To become a real art expert, all you really have to do is saturate yourself with endless thousands of works of art and let them do the rest. Just look and assess how a particular work stacks up against the entire output of that artist, against the work of his generation, and against the work of his century and his civilization. Simple, eh?

I'm not going to follow every niggling item on my checklist. Here are the important things to do: write down your flashing first impression; make a detailed (and invariably boring) description of every inch of the piece; find out the story behind its creation; discover what the artist had to say about it, including, hopefully, why he created it; establish its history; read the key publications about it; give other critical opinions a passing glance; pin down its style; find out its condition; ask how much it's worth.

I'll not lead you through a battery of scientific tests, because *American Gothic* is in very good condition, and that fine condition counts for a lot when you assess its quality and worth. I will also leave out determining whether *American Gothic* could be a forgery. For whatever it may be, it's not a fake.[5]

3.

My First Impression

I still have what I wrote down the first time I saw *American Gothic* in the flesh in the glorious Art Institute of Chicago's main American gallery in the early 1960s: "Nicely tight. Powerful reality and witty visuals combined. Late Gothic European style."

I had seen the picture earlier in a reproduction in 1948, when I was seventeen years old. The occasion was a conversational French class at an elite prep school where we were chatting away about impressionism, postimpressionism, and cubism. My teacher, cleverly mixing up French with art history (this was one helluva sophisticated school), was extolling the "soaring" innovations of Monet, Manet, Braque, and Picasso. We all soaked it up. Then, to show us teenagers the other side to the French mastery of painting, he showed us a life-sized poster of Grant Wood's *American Gothic*. He

launched into an entertaining slash-and-burn of this "triste" example of midwestern American provincial art and the banality of realism. He was trying to teach us new conversational idioms, with grown-up vocabulary like "merde," "cochon," and "imbecile," all of which he applied to the picture. We all really soaked that up.

I made sure I wrote each new word down, and was thankful that it wasn't my turn to be called upon because I was transfixed by the image. I cannot recall precisely what my instant impression was at that young age except that I remember how strikingly real this severe-looking man and his thoughtful companion were to me. He, especially, was serious and intriguing. I wanted to chat with the couple—not in French, and certainly not mumbling "merde," "cochon," or "imbecile"—and learn who these fascinating people were and what they might be thinking. I never forgot the image.

4 .

BEING FORCED TO LOOK

Almost as valuable as that first quickie impression is writing down a detailed, deliberately pedantic (meaning, face it, niggling) description of the work. So as not to slow things down, I'll present the gist here up front and then present my full description at the end of the chapter.

The purpose of this exercise is to force you look at every millimeter of the work, front, back, and sides, and walk right inside the artist's mind.

What's on the back of a painting can sometimes produce some good clues—the artist's real signature, notes about why he painted the piece, stickers that might indicate provenance or dealers through whose hands the painting may have passed, or exhibitions where it may have been seen. Grant Wood did write some notes on a portrait of his mother he did a year

before *American Gothic*—actually, some inaccurate remarks about how it had been subjected to overheating because of a spotlight trained on it. But he didn't write any secrets on the back of his most famous painting, I am assured by the curator of American paintings at Chicago's Art Institute.

What my lengthy written description of the painting does for me—and what your description will do for you—is alert me to certain key details. For details are all-important in the mature works of Grant Wood, and I might not have noticed some of them had I not pored and pored over every inch of the of the picture's surface.

Such as the sky, for one thing. I find the celestial blue peculiar. It's utterly without atmosphere or climate. It's unblemished and untinted by even a smidgen of haze or pollution. It struck me that perhaps Wood didn't intend this to be a real sky at all but something spiritual instead. This is both a pre–Industrial Revolution sky and something rather religious, too.

I am reminded, in fact, of the skies in some religious works of Northern European painters of the late fifteenth century—such "late Gothic" painters as Jan van Eyck and Hugo van der Goes. I wonder if Grant Wood had ever actually seen Hugo's *Portinari Altar* in the Uffizi in Florence or visited Ghent to see van Eyck's monumental *The Adoration of the Mystic Lamb* (Fig. 2, page 19). In the *Portinari Altar*, the sky in the central panel depicting Christ is almost identical to the limpid pure sky in *American Gothic*, whereas the skies in the side panels, with its saints and secular

donors, have clouds. In other words, Christ brings redemption, the end of death, and clear, gorgeous skies forever. Similarly, in van Eyck's complex masterpiece the sky above God the Father, the Virgin, John the Baptist, and the choirs of angels are all crystal clear blue like *American Gothic*, whereas the panels where mortals are depicted are, again, cloudy.

What time of day is it? From the shadow on the roof of the barn and porch (where the only accent of "livability" is the blue, rolled-up screen), it looks like late afternoon. What season? Probably summer.

When suffering through enforced description, I always look to see what's at the center, or near the center, of the picture. In *American Gothic*, I find the sharp-as-a-tack middle tine in the three-tined pitchfork. That gets me to looking and thinking about that pitchfork, and that's when I picked up on the tricky optical illusion Wood created.

The pitchfork itself is odd. It seems too thin to be a working farm tool. There's no sign of rust or blemish; it's as if the fork were made out of pure silver. The metal coupling in which the wooden handle sits is oddly insubstantial; one smack on the ground and the fork would be off its handle. I wonder how many pitchforks Grant Wood had ever slung hay around with? I suspect that he painted the tool not from life but from vague memory. Or from a photograph that he misinterpreted. Or, perhaps, the pitchfork was never intended to be real, only its essence, as some kind of symbol.

The optical illusion is subtle and clever. Look at the trident where it meets the coupling. It bows either in or out; is convex or concave; is going toward you or

away from you. The center tine cants either right or left as you look, thus making for a slight but unmistakable movement within the static image. This illusion might well have been crafted to reinforce the artist's desire to make the viewer wonder if the impassive man is about to be friendly or unfriendly. With the optical illusion, this sense of ambiguity is enhanced. Too, with the tines of the pitchfork nicely positioned just off true vertical, more energy is added to the painting.

It all adds up to a subtle sense of movement.

The man's right hand seems seriously out of proportion to his body, which could be either a symbol of his dominance or just the way his actual hand was. Interestingly, cover the hand with a piece of paper and the balance and a great deal of the power of the painting falls away. The hand is a crucial element. Could there be a reason why it is so prominent? Definitely, it turns out.

I am amused at Grant Wood's "reflection" of the pitchfork in the faded, soft blue-beige of the overalls, as well as in the ogive window in the second story of the house. I wonder where that reflection could have come from. (We'll find it later when we hunt for the visual sources for the painting.)

The man's glasses catch my attention for several reasons. They look like they are crafted of silver or polished steel—more costly than a farmer might be able to afford—and there isn't the slightest hint of prescription glass in the frame and therefore no distortion of the man's powerful eyes. It may be that the artist feared any skewing of the eyes. (In one of

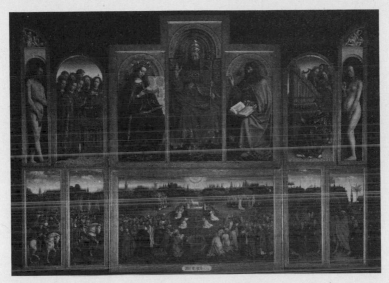

Fig. 2. *The Adoration of the Mystic Lamb*, Jan van Eyck. (Image provided by Art Resource, Inc.)

Wood's self-portraits, his thick glasses don't distort anything behind the glass, either.)

I am also struck by how the man's eyes are almost without irises, whereas the woman's eyes are vivid blue. That makes me suspect that Wood knew the female model a lot better than the male.

I was drawn to the man's face and how marvelously painted it is. His visage, especially the lower part, is equal in quality to any face in any of America's finest portraits. The intense observation and perfect rendering of the lines in that long, oval, "Gothic" face, the thin, firm but not inimical lips, and the wattles of age at the neck are as well conceived as anything by Thomas Eakins or John Singleton Copley. The passage reminds me of Albrecht Dürer's Nuremberg self-

portrait of 1500, or the bearded, kneeling shepherd in Hugo van der Goes's great *Portinari Altar*. (Could Wood have actually seen these works? We'll have to check.) There's not a trace of a stubble on the man's face, which possibly indicates that Wood didn't want to have even a hint of time in a painting he hoped would be timeless. Compared to the woman's face, the man's is flatly frontal, making me think that the intention was to make his face look like a photograph, perhaps like a stiffly posed portrait out of some old family album.

Only when I looked intently at the man's face and his overalls, however, did I pick up on the striking gold collar button, reflected, in turn, by the silver and gold-gilded lightning rod at the apex of the house's roof.

That gets me thinking about how the peaked roof lines point to the man and woman, no doubt intending to underscore their close relationship to each other. They are literally bonded together by the roof of their house. The house and couple are utterly unified, like the statues on thirteenth-century cathedrals.

I take the woman to be in her late twenties, early thirties, with a face that seems too oval to be natural. I figure Wood also elongated it to make it seem more Gothic.

I am fascinated by the way the woman's naturally blond hair is pulled back so stringently yet so impishly ("provocatively" would be too strong a word for this painting), allowing one sinuous curl to fall freely. Beneath the impassive expression, she could be a lot of fun, I think. That idea is reinforced by the cameo she is wearing at her throat. A magnifying glass reveals it to be the head and shoulders of a young woman holding

what appears to be a leaf or flower. At first, I take the image to be a goddess, perhaps Ceres, goddess of agriculture, but then I recognize it simply as a vibrant, young woman, perhaps even an actress. Being a seasoned connoisseur, I immediately see that the style of the cameo is Italian, late nineteenth century—typical Vittorio Emmanuele art nouveau style. I wouldn't be surprised if the cameo was a treasured Wood family heirloom. I liked the way its rusty red background plays off the more solid, down-to-earth red of the barn, which is so meticulously painted that you can almost count the rivets on its corrugated tin roof. The cameo is *her*, whereas the pitchfork is *him*, I think. He's looking right at you, straight as an arrow. She's looking away—perhaps in the hope of someday going to Italy, or wherever. What exactly is her expression? To me, it's one of patience and contemplation. Far from finding it annoying or peevish, the way she looks slightly away, in fact, is highly effective.

After spending several days poring over the details of *American Gothic* and writing them down, I sum up my general impression of the work: it is clever, meticulously planned, fabulously painted, a study not just of two specific people but of a slice of humanity, perhaps of a bygone era but still one resonating today. It's an amazing depiction of a couple, a setting, a mood—all proclaiming something ancient and enduring, and, oddly enough, something sacred.

5.

IN GREATER DETAIL

The backdrop of *American Gothic* is a simple, white wood frame house with an inviting porch, although there is no furniture of any kind on it, with a blue screen rolled up between two thin columns on the right-hand side. The prime architectural feature of this humble abode is its second-story Gothic ogive window set dead center above the porch. It consists of two smaller, intersecting ogives, with a diamond shape between at the peak, and two rectangles below, the mullions making a simple cross shape. On the first floor below are two larger, side-by-side rectangular windows. Each consists of four smaller rectangles, with the mullions of the left-hand, visible window behind the couple again making a cross shape. The roof of the house and front porch is shingled; the roof of the porch to the left is covered with corrugated tin. The

dozens of shingles are individually painted; red molding outlines the house's peaked roof. It's the angle of this peaked roof that binds the man and woman together, by bisecting their bodies.

On the left-hand porch are two common terra-cotta pots; in the one there's a "snake plant," and in the other begonias.

A red barn constructed of wood and tin stands off to the right. The sun-drenched, browned-out corrugated tin roof of this barn is meticulously painted, so that one can see clearly defined rivets. The shadow of the roof would seem to indicate that it's late in the afternoon.

The other structure in the picture is a steeple, as sharp as the tines of the pitchfork, piercing the trees on the left-hand side of the painting.

The trees, in full leaf, are rounded, highly abstracted shapes—I might call them "streamlined"—which give a quick impression of abundant summer foliage. They are painted in a far softer manner than the rest of the painting. This is the subtly different style of the overall painting, and may indicate that Grant Wood was in the process of changing his style when *American Gothic* was executed.

It is a gorgeous, sunny afternoon in what would seem to be early summer, when the heat has started to wane. Yet, the exact date and time are of little interest to Wood.

The place could be virtually anywhere in rural America. The year is not known, but the mood and the trappings—especially the architecture of the house—seem to suggest the late nineteenth century.

The face of the frontally staring man at first looks very tightly painted—like enamel—but, on closer examination, isn't, especially when looked at through a magnifying glass.

Wood has laid in a complex—and extremely skilled—series of glazes. A glaze, briefly, is a layer of oil paint that is allowed to dry, then is varnished, allowed to dry again, then is painted over again, allowed to dry, then varnished again. It could be that Wood was trying to approximate the glazing techniques that were all the rage in the sixteenth century, when Venetian master Titian perfected the technique. It was an extremely slow process—Titian is said to have allowed an individual layer to dry for six months before applying the next, first sandpapering it to a mirrorlike finish. These subtle, myriad glazes create an amazing depth of color, making the man's face in *American Gothic* look as if it were real flesh and blood.

The man is only slightly tanned, suggesting that he might be a "gentleman farmer" who doesn't labor regularly in the open fields. This gentle tan makes the ruddy complexion even more realistic. The great bald forehead is, on intense scrutiny, a virtual landscape of furrows, diminutive hills and valleys. (If he *is* in fact a farmer, and I'm not yet convinced he is, this clearly delineated treatment suggests that the man's noble brow is also a fine parcel of farmland—or is this going a bit too far? Yes, probably.)

Just over the man's right eyebrow, the furrows admirably spell out a certain skepticism—one, however, of a philosopher, not a farmer. Over the left

eyebrow, there's a beautiful passage of slightly more whitish paint that gives his face a surprising glow.

The man's hair is sparse, and peculiar in that there are no traces of sideburns. I mean, there's a disconnect between the thin barrel vault hairline at the crown and the hair on the sides of the face. I wouldn't be surprised if the model was completely bald. In fact, closer examination of the right side of his head just over the ear shows that the painter flubbed "hair anatomy." There's no way the hair at the crown on the right side could properly meet the hair just above the ear, whereas on the left side there's a smooth transition between the two.

Grant Wood also had trouble painting the ears. They simply are not very good, being overly summary and barely anatomical. (A glance at other Wood portraits and figure paintings shows that this inability to do ears is a "signature"—he just never got them right.)

What's this guy's facial expression, anyway? He's placid, yes, but his expression is just a knife-edge away from either breaking into a smile or sinking into a scowl. He is placid rather than dour, immobile rather than thickheaded or dumb, at rest rather than tense. To me, he seems to be highly intelligent, even learned, a rural citizen who is at first mistaken for being a bit behind, a bit provincial, but who then surprises one by making some dazzling observation. Everybody knows this "I am just a simple country lawyer" type.

His clothing is vital to the mood of the picture, and I suspect Wood chose the elements very deliberately.

The glinting gold collar stud, the punctiliously painted white button, and the precisely measured

green vertical stripes are clear signs that this is a dress, or "Sunday," shirt—even without its collar, which the man seems to have just removed. The refulgent golden stud and button are small still lifes on their own. The stud is picked up in the silver-and-gold knob of the lightning rod on the peak of the roof, making for yet another visual pun among many in this complex work. The shirt's vertical stripes blend in and reinforce the upright slats of the house and the tines of the fork.

The man's black jacket—also "Sunday" garb—is, strangely, not modeled at all, with only the barest hint of a collar. I speculate that it might be not so much a coat but a reference to the jet-black backgrounds that one sees in a number of German or Flemish portraits of the late fifteenth and early sixteenth centuries. If true, this would go along with my increasing feeling that this painting is heavily influenced by late Gothic German and Flemish paintings.

The man's overalls are a tour de force of painting technique. The blue color is soft, the texture crisp but worn, highlighted by passages of yellow-beige paint. It's amusing how the vertical, Gothic shape of the pitchfork is repeated in the overalls' seams, as well as the shape of the upstairs ogive window in the overalls' curved crease.

The man's large hand is slightly more worked than the face. It is vital to the force of the image. Without it, the sharp sense of reality and tremendous energy of the painting would be seriously impaired. And, for sure, if the picture plane showed more of the couple the effect of the work would be weakened.

The woman, in her late twenties or early thirties, is handsome rather than pretty or beautiful, with good bone structure, gorgeous blue eyes, and natural blond hair. Contemporary records might help establish her identity.

Two things are especially striking about her: one is the severely pulled-back hair with its emphatic center part, and the other is the sinuous, snakelike curl falling near her right ear, which, by the way, is as poorly drawn as the man's. She is looking just slightly to her left, not that she's been alerted or alarmed by anything, however.

The shape of the woman's face I find somewhat odd. It's almost an enforced oval, like some kind of formulaic drawing. It's not quite anatomically correct, the only thing immediately coming to mind being the placid, composed, long oval faces of Hugo van der Goes (indeed, she could have stepped out of the *Portinari Altar*) or certain works by Hans Memling. I suspect, in fact, that this face is not exactly that of the living model. Too, the painting of her face is smoother, less glazed, than that of the man. And yet, the roseate hues on the right side of her face next to her ear are truly splendid.

The woman's clothing also seems to have been carefully selected by the artist. It's old-style, "country" calico with a down-home rickrack motif (again reflecting the ogive window shape) and a subdued pattern of dotted circles and white dots (which definitely refer to the man's white button, perhaps signifying that the man and woman are together—or am I finding things?). The pattern and color are picked

up by the dotted-circle pattern on the shade in the window, although the fabrics are not the same. And her white collar is prim and cautious. Yet the woman's clothing seems less "Sunday" than the man's, giving the impression that she's been in the house waiting for him to return from somewhere.

Finally, the signature GRANT over WOOD appears in the beige discoloration of the man's overalls to the right of the hand.

Grant Wood must have studied a number of great historical portraits, for he, like the Old Masters, restricted his palette to black, white, blue, a touch of red, silver, and flesh tone. And like the Old Masters' work, *American Gothic* is in every respect—in overall image and in myriad, impeccable details—a thoroughly stunning piece of work.

6.

STYLE

An important item on the checklist is to identify and date the style of the work.

Style, simply put, is the complex creative signature or personality of an artist, one that is far more complex than a handwritten signature. Artistic style is made up of hundreds upon hundreds of elements, ranging from the choice of certain colors and hues to the character of lines, the way the artist depicts ears and cuticles, the way a mouth is drawn, how the ears are rendered, drapery patterns and the exact way drapery is made to crinkle and fall, the size and form of eyes, the way the paint is applied, how shadows are delineated, etc.—the list is endless.

All styles can be dated—from a sliver of a drawing of a water buffalo on a slice of stone from predynastic Egypt to Pollock's *Autumn Rhythm*.

A well-seasoned connoisseur who has devoted years to looking at thousands of works of art can fairly quickly and confidently place a piece that has no written or illustrative history into a fairly small block of time in a certain civilization or country or artist.[6]

What if you came across *American Gothic* in the back room of a small art dealer in, say, Davenport, Iowa? Never published, never reproduced, no documents, no history. And, of course, without the signature, GRANT over WOOD, that we found near the hand. Where would you place it in art history and why—from style alone?

First, I'd tend to rule out China, since it doesn't look like a Han dynasty commission.

So, it's Western. Date? Anywhere from 1445 to 1945. That's a broad band, I know, but the work does have distinct comparisons to the styles of Jan van Eyck, Albrecht Dürer, Hugo van der Goes, Hans Memling, and some other of the Northern Renaissance boys. So, it's likely to be an artist who admired and wanted to emulate them. Part of the style analysis exercise later on might be to set aside photographs of those Northern Renaissance paintings that are closest to *American Gothic*.

Narrowing down a bit further, I'd say that from the pitchfork, the glasses, the clothing, and the Italian art nouveau cameo, the painting dates to the nineteenth or twentieth century, sometime after 1890 and before 1945. But the curiously "streamlined" round shapes of those trees are definitely not ninteenth-century, but a hallmark of the 1920s and 1930s, when artists turned sharply to the svelte, rounded, streamlined look and incorporated the look into human bodies and

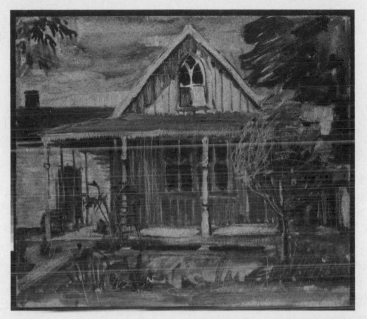

Fig. 3. The "Carpenter Gothic"–style house that caught Grant Wood's eye in Eldon still stands today. (Copyright © Estate of Grant Wood/ licensed by VAGA, New York, NY. Image provided by Art Resource, Inc.)

landscape elements. These curious trees show a touch of modernism.

What country? I'd definitely go America over Europe—North American, to be precise, for it doesn't have a Latin American beat—no tangos with this pair. And America over Germany. Why do I even mention Germany? Because during the Weimar years—the 1920s and 1930s—there burst forth, especially in Bavaria, a hard, meticulously realistic style that sprung up in opposition to the wild turmoil of expressionism. This style was called "the New Objectivity"—*"Die*

Neue Sachlichkeit," in German—and it looks something like Otto dix's *Self-Portrait.* (Maybe the artist had soaked up some New Objectivity works, especially the cool, linear, slickly painted efforts of Dix. Or, maybe the artist soaked up some late Northern Gothic painters the New Objectivity artists also admired.)

But that spindly frame house with its oddball Gothic window cries out, "America." There's nothing European about it—not even Gothic Chartres or Notre-Dame, for this is a faux-Gothic decorative device instead of an architectural statement. As a matter of fact, it's kind of a stage setting.

So, I'd go for United States and the 1930s. But where? Not the East. These stalwart, straight-laced characters just don't show up in the paintings of John Sloan, George Bellows, Reginald Marsh, or Edward Hopper. Not too many overalls in the works of those guys. This reeks of the pungent flavor of a farmland part of the country where there's a strong religious basis. The Great Plains.

Might that point to Grant Wood, the so-called regionalist from Cedar Rapids, Iowa, who produced some memorable works from 1930 until his premature death in 1942? Remember those sweeping farmland landscapes and the witty commemoration of the Daughters of the American Revolution?

Well, it just so happens that in Wood's well-documented body of work there is a striking portrait done in 1929 entitled *Woman With Plants,* actually a portrait of his mother, in which some stylistic elements are comparable to this work. And his mother wears the exact same cameo that this stern young woman is wearing. Plus, she is holding a "snake plant," just like

the one on the porch—you noted it and the begonia, no doubt, in your pedantic description, sitting on the porch just above the rickrack of her apron. And there's a landscape of 1930, *Stone City, Iowa*, in which for the first time in Wood's works trees of this bulbous, abstracted, streamlined shape appear.

So, this pitchfork painting is very likely an unknown oil by Grant Wood circa 1930.

See how easy it is?

But since we know almost everything about the genesis of *American Gothic*, we don't have to go down the style route. We can go straight to the documents.

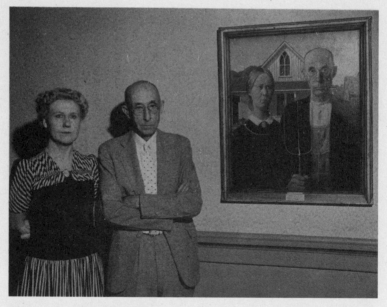

Fig. 4. Nan Wood Graham and Dr. Byron H. McKeeby posed with *American Gothic* only after Grant Wood had died. (Printed by permission of Cedar Rapids Museum of Art.)

7.

Genesis

Nothing makes a connoisseur's heart sing more sweetly than coming across records dating to the precise moment of the creation of a work. Think of having a letter in the synoptic, mirror handwriting of Leonardo telling precisely what he had in mind when he met the lovely young Mona Lisa. "She's pretty enough, but has this stupid teeth-baring smile, so I gave her a dab of the old mystery thing."

Records, writings, bona fide statements by artists about their works wipe out most art historical *horsegeschichte*. Virtually any statement by an artist is held sacred by connoisseurs, especially those made in the heat of the creative moment. Luckily, in the case of *American Gothic*, there's an abundance of contemporary documents that spell out in detail when, where, and how Grant Wood was inspired to create this

indelible image. We also have his own words about what he wanted the painting to mean, which show a few changes in what he had originally intended as he got stressed out about the picture. The further out in time from the moment of creation, the more Wood cleaned up the work's meaning and message. He seems to have enjoyed enhancing the aura of ambiguity that surrounds the work.[7]

In August 1930, when Grant Wood was just shy of his fortieth birthday, a dear friend and mentor, Edward Rowan, asked him to drive down to the tiny town of Eldon (population 1,700), nestled in southern Iowa along the fertile Des Moines River. Rowan, a sage and a canny booster of Grant Wood and other local artists, had started up an experimental summer art school, gallery, and library in Eldon. He wanted Wood to demonstrate for local art lovers the challenges and tricks of painting outdoors in the classic French impressionist style, what is called "en plein air."

Wood agreed to come. He was indebted to Rowan, he loved teaching, and he was a bit of a ham—he'd established a miniature theater in his meager digs in Cedar Rapids where he acted in various plays, both the classics and his own antic comedies.

In a poor farming area of Eldon, at the northeastern edge of town, on a small street between 4th Avenue and Burton Street, Wood spotted a small, five-room farmer's house. It caught his waggish eye first for its decorative promise: ". . . our cardboardy frame houses on Iowa farms have a distinct American quality and are very paintable. To me their hard edges are especially suggestive of the Middle West civilization."[8] He also

thought the house was a bit silly. As one of his biographers, Darrell Garwood, reveals: "He thought it a form of borrowed pretentiousness, a structural absurdity, to put a Gothic-style window in such a flimsy frame house."[9]

This house, which still exists, had been designed and constructed in 1881–82 by local carpenters who had enjoyed a brisk house-building boomlet in the late nineteenth century.[10] The style is called "Carpenter Gothic," and is notable for the squat design of the porch and the portly Gothic-style window in the upstairs room. "This [house] gave me an idea . . . to find two people who, by their severely straight-laced characters, would fit into such a home," Wood explained.[11]

He made a loose oil sketch on composition board—some 13 inches by 15 inches (Fig. 3, page 31). Whether this was the landscape he did plein air for the locals, I don't know. He asked Mrs. Rowan to take a photograph of the house so he could get all the architectural details recorded right down to the nails in the boards and the shingles on the roofs. This desire to record every detail was something new for Grant Wood, who had decided some months before to give up his "impressionist" style and try to merge semiabstract decorative patterns with the realism of storytelling. He was especially keen on getting the details of a scene absolutely right—like the late Nothern Gothic artists whom he revered.

The oil sketch makes the actual house more Gothic than it is.[12] The ogive window is thinner, higher, more elongated. The roof is more vertical. There are trees, some undisciplined shrubbery in the yard, and a ladder

leaning upright against the porch, which he'll get rid of in the finished painting. He also will have added the red barn by then.

The quick oil, painted in a loose, watercolor-like technique with turpentine washes, was followed by a tiny pencil drawing on the back of an envelope. It's no larger than a space for four postage stamps, only 4³/₄ inches by 3¹/₂ inches.¹³ This minute drawing is gridded so that it can be transferred to a larger format. Wood adopted the grid technique in 1927 when he was designing a large stained-glass window for a war memorial in Cedar Rapids.

As if he wanted to legitimize his idea, make it "official," or "museumy," Wood drew an elaborate double frame for the painting-to-be and wrote in the title, "American Gothic."

The house in the drawing has been made even more Gothic than in the oil sketch. It's more uplifting, or more "anagogical," as the twelfth-century inventor of the Gothic style, Abbot Suger, of Saint-Denis in Paris, put it. Higher and thinner is closer to the Almighty— more spiritual. To leave no doubt that these characters are Gothic, each has its own slender Gothic window near its head.

The sketched man and woman are, for sure, the "severely straight-laced American Gothic people" Wood wanted. As he said, "I simply invented some American Gothic people to stand in front of a house of this type."¹⁴ He clearly intended them to reflect a pair of grim, elongated, stiffly frontal statues carved into some splendid portal of a French cathedral. We know this because Wood showed the woman he chose as his

model a series of pictures of Gothic stone carvings from just such a cathedral.[15]

The man holds a rake. When Wood gets to the oil painting, he decides it is neither sufficiently farmlike nor "anagogical." A country gentleman holds a garden rake, a genuine farmer holds a pitchfork.

The dress code in the tiny drawing is "farmer," and pointedly late nineteenth or early twentieth century. The woman, who is an unambiguously frontally faced full partner of the frontally faced man, wears a prudish collar not very much in style in the fading days of the flapper. She also is adorned with the cameo, such an important element in the finished product.

The facial expressions of these Gothic portal "sculptures" are neither neutral nor passive; they are downright sour, even ornery. Nobody we'd like to bump into, that's for sure. Downcast-mouthed, anal types, they have nothing of the crafty ambiguity and entertaining mystery of the characters in the final work.

Finding these folks in real life wasn't easy, Wood stated. "I looked about among the folks I knew around my home town, Cedar Rapids, Iowa, but could find none among the farmers—for the cottage was to be a farmer's home."[16]

He had his eye on a particular Cedar Rapids spinster for the woman, but apparently never cranked up the courage to ask her.[17] So, "I finally induced my own maiden sister to pose and had her comb her hair straight down her ears, with a severely plain part in the middle."

For his "farmer," Wood searched close to home for the perfect model. "My quest finally narrowed down to the local dentist, who reluctantly consented to pose."[18]

The dentist was Dr. Byron H. McKeeby. Sixty-two years old, McKeeby was a pleasant, retiring midwesterner, not dour or threatening in the least. He was well read, and enjoyed philosophy and the classics. He liked to travel, and although he wasn't anti-art he suggested that art was maybe a bit high falutin for him.[19]

McKeeby and Wood had been close friends for years, and Wood, a gifted decorator, had redone McKeeby's office and home. To pay for some bridgework, the artist had given the dentist a painting he'd done of a bridge in Paris, ironically enough, following a trip to France in 1926. And Wood was constantly going to see McKeeby for a serious gum problem, in fact, and seems to have studied McKeeby very closely through many long hours in the patient's chair.

After one such session, Wood startled the otherwise placid McKeeby by saying, "I like your face."[20] McKeeby drily observed that it probably wasn't because of his matinee idol looks. Wood would only remark, "Because it's all long straight lines."

That remark makes me a little suspicious. Grant Wood was clearly intrigued by Byron McKeeby's dolichocephalic head before he spotted the "cardboardy" Eldon house. I think it's possible that once Wood saw the Gothic house, he instantly thought of his dentist friend, and was determined to place that memorable long-lined face next to this long-lined house. With the puckish jokester Wood, anything was possible—he could be downright mischievous.

Another time in the dentist's chair—again, before he'd seen the Eldon house—Wood had blurted out, "Let me see your hand." He grabbed the dentist's very

large hand, which also had exceptionally large knuckles and an unusually long thumb. He studied it for so long that McKeeby later cracked to a friend, "I thought maybe I wasn't going to get it back." Wood kept turning the hand over and over, and when at last he let go he said, "You know what that is? That's the hand of a man who can do things."[21] That explains why the hand in the painting is so large and seemingly out of proportion to the rest of the body, because it is an accurate portrait of McKeeby's hand. As I suspected in my detailed description, there was a reason for the large size—in this case, verisimilitude.

When asked to pose for *American Gothic*, sister Nan was reluctant at first. She had heard Grant Wood "talk to half a hundred people about his aims," which was, in part, a satire, a gentle one surely but a satire nonetheless, of straight-laced, Bible Belt Gothic folks. But her brother assured her that he'd change her face so that no one would ever link her to the work. She scoffed but finally agreed to pose anyway.

McKeeby was a harder sell. According to Wood biographer Darrell Garwood, "To get this remarkable man into the painting became absolutely essential, but when Grant asked him to pose, Dr. McKeeby refused. A modest man, honest and sincere, he said he was a dentist and didn't intend to dip into art. Grant kept after him, and Dr. McKeeby, with good nature, finally agreed—but only on the condition that no one would ever recognize him. It was after the 1929 crash; business was beginning to fall off a little; it didn't require many trips to the studio. 'God knows I can't be the beauty you're after,' he said."[22]

Wood's assurances of anonymity proved flimsy. Once the painting was shown to the public, both individuals were immediately spotted. Nan was so irked she painted a travesty of the painting, putting her brother in the middle of a trio in front of the Eldon house, with two tines of the pitchfork sticking up behind his head like horns.[23]

No one who knew McKeeby failed to link him to the painting. One story has it that once when the dentist was sitting in the dining car on a train a thousand miles away from Cedar Rapids, a couple inquired, "Are we by any chance sitting across from one of Grant Wood's characters?"[24]

McKeeby was furious at Wood for not masking his identity, and an acerbic argument ensued about the painter's "promise" of anonymity. Patients began joshing him, "You aren't going to use a pitchfork on me, are you?"[25] Although the two remained friends, the relationship was never quite as warm as it had been before. Eventually, McKeeby concluded that Wood had not lied to him. For years, he would neither confirm nor deny that he was the model. In 1935, however, he finally did admit to his role. When asked what he thought of the expression on the face of his character in the painting, he replied that "a dentist is like anyone else at work and may often be wondering about his children or why he should pass his years in this way." Asked if he liked the work or not, McKeeby thought a minute and then drew a long breath. "Well, sir, I'd just rather not see it at all."

In 1942, after Grant Wood had died of cancer, *American Gothic* was exhibited at the Cedar Rapids

Art Museum (it had been there once before in 1931), and Wood's prime patron, David Turner, got the idea of having Byron H. McKeeby and Nan Wood Graham pose for a photograph in front of the painting.

As Darrell Garwood describes the event, "Dave Turner put on the pressure. He used persuasion, and Dr. McKeeby liked to be obliging when he could. Dave pointed out that it might never happen again that the dentist, Nan and the painting would be in Cedar Rapids at the same time. 'Hope some day I can use my face to make such a fellow as Grant Wood a more famous painter,' the funeral director declared. Dr. McKeeby wavered just enough. Then Dave called Mrs. McKeeby and asked her if she had any influence over her husband. Mrs. McKeeby said she did. Dave explained about the photograph, and Mrs. McKeeby promised to have her husband there at the appointed hour. Turner sent a police escort to Dr. McKeeby's office, in an outlying shopping center, and they brought him downtown with sirens going full blast. The photographs were taken"[26] (Fig. 4, page 34).

The photograph shows how Wood had drastically changed his sister's face, making it far more oval, elongated, thinner than her actual bone structure.[27] McKeeby is virtually identical to the painting, despite the passage of twelve years—except for the fact that in real life he was totally bald, as I had suspected when I wrote down my detailed description.

The resemblance shows what an exceptionally gifted Grant Wood the portrait painter was. He captured McKeeby's honesty, nobility, taciturnity, and the

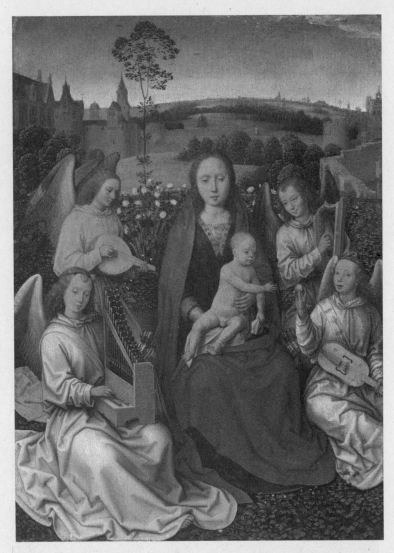

Fig. 5. Flemish Northern Renaissance master Hans Memlin's depiction of the Virgin and Child, in his *Saint George*, hangs in Munich's Alte Pinakothek. (Reprinted by permission of Alte Pinakothek.)

Fig. 6. The center panel depicting the Virgin, Child, and angels (Fig. 5, page 44) is reflected in the Archangel's shining breastplate in a side panel.

Fig. 7. The pitchfork is also "reflected" in the farmer's overalls.

wry sense of humor that was carefully hidden behind the passive facade of his face.

Wood didn't make notes about the intricate crafting and stitching together of the complicated elements in *American Gothic*, but one can work with what he did say, plus what those close to him said, and be pretty sure what his process was and what he intended the painting to mean from the beginning.

To emphasize the nineteenth-century flavor of *American Gothic* and its "primitive" nature, Wood studied family photographs. As he would confide to an interviewer a decade after the painting was done, ". . . these people are tintypes from my own family album."[28]

As art historian Wanda Corn cleverly points out, there's a photograph in one of Wood's albums that is a perfect model for the frozen pose so typically suffered in early photographic sessions. The woman is Maria Littler Wood, and her white collar and cameo brooch may have directly inspired the woman's collar and brooch in the painting.[29]

Wood spent a fair amount of time getting together the "wardrobe." For McKeeby's shirt, he scrubbed and ironed an old shirt he found among his painting rags.[30] For the rest, he went to his favorite source, the Sears Roebuck mail-order catalogue. "Gradually as I searched," he said, "I began to realize that there was real decoration in the rickrack braid on the aprons of the farmers' wives, in calico patterns and in lace curtains. At present, my most useful reference book, and one that is authentic, is a Sears Roebuck catalogue." That's where he got "the prim, colonial print

apron my sister wears and for the prim, spotless overalls the dentist has on. I posed them side by side, with the dentist stiffly holding in his right hand a three-tined pitchfork. The trim, white cottage appears over their shoulders in the background."[31]

So, what about all that Northern Renaissance spirit I felt imbedded in *American Gothic*? Any substance to that?

It's undeniable that Grant Wood had been fascinated by late Northern Gothic paintings for much of his creative life. He especially admired Hans Memling, whom he said he had studied "assiduously." In an interview about his creative processes in 1932, Wood stated he'd been attracted by the rationalism involved in late Gothic and Northern Renaissance "methods of designing cohesive compositions overlaid with a multiplicity of details." He added, "The lovely apparel and accessories of the Gothic period appealed to me so vitally that I longed to see pictorial and decorative possibilities in our contemporary clothes and articles."[32]

If I were asked to set aside all Northern Renaissance works that seem to "appear" in some form in *American Gothic*, I would make this list:

• A large, fully mature altarpiece by Memling depicting the Virgin and Child surrounded by a choir of angels. It's in Munich's Alte Pinakothek (Fig. 5, page 44). In the "donor" panel on the right side of this meticulously painted work (in which the sky above the Virgin is as limpid and clear as that in *American Gothic*), the Virgin's face is similar to the exaggerated long oval of

Nan Graham's face. Moreover, Archangel Michael is shown in glorious, solid silver parade armor, holding a lance that is spiking the Devil— here, a gray, beaten-down dragon. The amusing part of the archangel's shining breastplate is that you can see reflected in it virtually all the details of the Virgin, Child, and music-making angels sitting in front of him (Fig. 6, page 45). Is it possible that Grant Wood was inspired by such exceptional detail to paint the odd "reflection" of the pitchfork in Byron H. McKeeby's overalls (Fig. 7, page 45)? But did Wood ever see Memling's relatively obscure work?

- I also see reminiscences of the astounding frontal self-portrait made by Albrecht Dürer in his twenty-eighth year emulating Christ, (Fig. 8, page 50) also found in the Alte Pinakothek in Munich. There are striking similarities in frontality between this face and that of McKeeby. If Wood had ever been in Munich, he might have seen the Dürer. Did he?

- The famous *Portinari Altarpiece* that the Fleming Hugo van der Goes painted for the Medici banking representative in Bruges, Tomasso Portinari, and which is now in the Uffizi. The face of Nan Graham is extremely close stylistically not only to Mrs. Portinari, in the panel on the right, but also to the face of the Virgin, in the central panel. Was Wood ever in Florence?

- A number of Memlings in the Pinakothek of the Germanisches National Museum in Nuremberg.

Was the Iowa farm boy ever in that city?

- The grandiose, many-paneled altarpiece *The Adoration of the Mystic Lamb*, painted in infinite detail by the master Jan van Eyck around 1425, and enshrined today in the Saint Bavo cathedral in Ghent. Could Wood have traveled there and seen and admired it (Fig. 2, page 19)?

In all of these works, there is a hierarchical, almost dogmatic flatness to the figures, a penetrating depiction of faces, and the most meticulous rendering of details, all of which appear, however modernized, in *American Gothic*. The question is, was Wood interested in Northern Renaissance works, and could he have been in Belgium, Florence, Munich, and Nuremberg? We'll find out.

What, exactly, was Wood trying to achieve in *American Gothic*? What did he want to say? From the quotes, we've already seen that:

- He wanted a vertical play of visual elements. In fact, he claimed he was toying with the idea of another oil painting that would be primarily horizontal. As he said, "It was my intention later to do a Mission bungalow painting as a companion piece, with Mission bungalow types standing in front of it. The accent then, of course, would be on the horizontal instead of the vertical."[33]
- He wanted to commemorate the decorative "Carpenter Gothic" house.
- He wanted to place in front of that house a

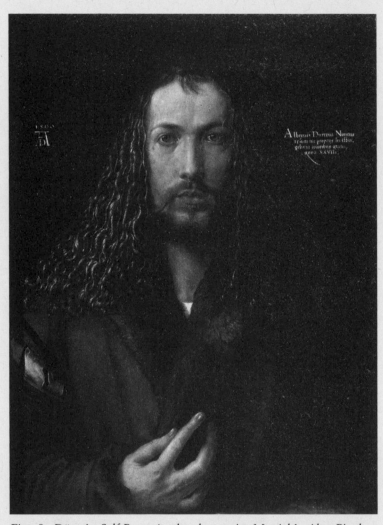

Fig. 8. Dürer's *Self-Portrait* also hangs in Munich's Alte Pinako-thek. There are striking similarities in frontality between Dürer's face and the farmer's face in *American Gothic*. (Image provided by Art Resource, Inc.)

specific man, Byron H. McKeeby, and a woman—early on, Wood would say man and wife, and later, father and daughter—who in their physiques and physiognomies would also be Gothic in style and spirit.

- He wanted the painting to be scrupulous in all details, a kind of Iowan Hans Memling. At the same time, he wanted to fill the work with a variety of visual puns.
- He was toying with a gentle satire of the place and the people.

Biographer Garwood puts words in the artist's mouth: "Grant intended to satirize the narrow prejudices of the Bible Belt, which includes southern Iowa. He had occasion to deny this later on, but since he was an admirer of H. L. Mencken, Sinclair Lewis and George Bernard Shaw, it is easily understood." The clincher for Garwood was when he learned that Wood was thinking of other subjects, like a Bible Belt revival meeting and a circuit-riding minister, which to Garwood had to be satires of some kind.[34]

But Wood himself always hedged the issue. "There is satire in *American Gothic*, but only as there is satire in any realistic statement." And he observes, "I have no intention of holding them up to ridicule." Yet he also said, "I admit the fanaticism and false taste of the characters in *American Gothic*, but to me, they are basically good and solid people." Adding, "These people had bad points, and I did not paint them under."

The bottom line for me is that what we have in *American Gothic* is a tightly, exquisitely painted

"theme" portrait of the highest conceivable quality that ranks on a par with any of America's most superior portraits, and yet with its own gentle, mischievous, satiric tone. It is full of sophisticated reflections and visual puns, and it renders homage to a golden age of art—the late Northern Gothic period—without slavishly aping it.

American Gothic is a depiction of a real house, a real man, and an imaginary woman—the unvarnished portrait of Byron H. McKeeby with a "medieval" mate by his side. And she—at once doughty wife, spinster daughter, and late Gothic Madonna—transforms and broadens the portrait of a specific man and house into a portrait of a way of life, possibly a totally lost one, but a way of life that nonetheless possessed both admirable qualities and qualities that one needs be wary, even distrustful, of.

In short, *American Gothic* is a crackling, iron-hard yet sinuously soft killer-diller of a painting.

But what would the public think?

8.

THE SHOW

Grant Wood, knowing he'd never finish *American Gothic* in time to make it into the exhibition at the Iowa State Fair, decided to submit the picture to the prestigious annual paintings and sculpture exhibition at the Chicago Art Institute, along with a landscape, *Stone City* (Fig. 9, page 55), which had already received first prize at the state fair.[35] The likes of *Stone City* had not been seen before in Wood's art, or, frankly, in American art. It has been one of the most overlooked paintings of the first half of our century, no doubt because of the popularity of *American Gothic*.

Stone City is a "portrait" of a tiny village almost hidden in the hills surrounding the Wapsipinicon River Valley (the "Wapsie," as it is known among local inhabitants). The town is several miles from Wood's birthplace, Anamosa, and gets its name from the

abundant limestone quarries, which were virtually abandoned in the late nineteenth century with the advent of Portland cement.[36] Still, if you stand on the hill today where Wood did his watercolor sketch, starting on the left you'll see the church, the bridge, the winding road slithering up, up and away into the middle distance, the gash in the hillside where the lime-stone was quarried, and even some of the deteriorating cranes used to quarry it.

Wood had never painted anything like this before, and it marks a clean break from his past. His former style was a kind of fuzzy-wuzzy, plein air, pseudo-impressionistic, or, at times, Seurat-wannabe, applying small rectangular slashes of color. In the portrait of his mother, *Woman With Plants* (Fig. 10, page 62) painted a year earlier, a few hints of the stark stylization and chain of patterns—those oddball (yet compelling) tennis-ball trees and abruptly rolling hillocks and chunky buildings—appear. The portrait had been shown at the Chicago annual exhibit in 1929, and although it received no prize and not much public attention it was selected nonetheless for a show that traveled around the country for several months.

Stone City is the birth of a totally new style, one which Wood embraced when he felt frustrated by the lukewarm reception of a large stained-glass window he'd fashioned for a war memorial in Cedar Rapids and was depressed that his art was going nowhere. His creative juices had been reinvigorated during a three-month trip to Germany to oversee the making of the stained glass, however, when he saw dazzling works by his revered Northern Renaissance masters and examples of the New Objectivity artists then in vogue.[37]

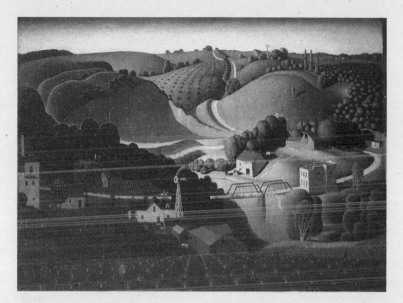

Fig. 9. *Stone City* had already won first prize in the state fair before Wood submitted it to the annual paintings and sculpture exhibition in Chicago along with *American Gothic. Stone City, Iowa*, 1930, oil on wood panel, 30¼ × 40 inches. Gift of the Art Institute of Omaha, 1930.35. Printed by permission of the Joslyn Art Museum. (Copyright © Estate of Grant Wood/licensed by VAGA, New York, NY.)

Stone City, about which Wood seems to have had doubts, calling it at one point "silly," shows every mark of his mature style. I mean, how he deftly reduces every natural element to a semiabstract, streamlined pattern, yet manages at the same time to deliver a sharp sense of realism. The painting is realism, but a kind of personal, surrealistic realism—a dream of what he imagined he saw in his childhood in the Wapsie Valley.[38]

The Chicago Annual—also called the American Artists Exposition—was big-time. The juries of

eminent artists and art experts from Chicago, New York, and Boston changed every year, chosen by the institute's legendary director, Robert B. Harshe, who during his tenure from 1921 to 1938 had brought the museum into modern times.

In 1930, there were two juries, one for paintings and the other for sculpture. Painting convened in Chicago, sculpture in New York City. Members started looking at the works in mid-October, deciding who would be in the show by month's end and announcing prizes totaling $5,050, which in the first year of the Great Depression was an extraordinary amount of money. The forty-third annual show opened to the public in November.

The out-of-town jurors for paintings were Wayman Adams and Maurice Sterne from New York City and Charles H. Woodbury from Boston. For sculpture, there was the renowned sculptor William Zorach.

The Chicago judges for paintings were Roy H. Collins, W. Vlad. Rousseff, and Percy B. Eckhart, who was the museum's legal counsel. For sculpture, there were Malvin Albright, Leonard Crunelle, and C. Hallstammar.[39]

Grant Wood may have just squeezed in over the transom. Wanda Corn, an indefagtigable scholar of Wood, recounts: "The jurors were divided over whether to accept *American Gothic*. Alongside other entries of modern still lifes, landscape and studio nudes, *American Gothic*, with its deliberate archaisms and small size [30 inches by 25 inches], appeared curiously quaint. But one juror's favorable opinion prevailed, and the painting . . . was admitted . . ."

I'm puzzled by her account, for Wood submitted two paintings, *Stone City* and *American Gothic*. The picture is not small but life-sized. And compared to the other lackluster entries in the show, it stands out as something of a beacon.

The report in the Cedar Rapids Gazette on October 28, 1930, seems clearer: "Two paintings by Grant Wood, local artist, have been accepted for the American Artists Exposition which opens at the Art Institute in Chicago on November 30, according to word received here. Acceptance of the two canvases is said to be an exceptional honor as hundreds of paintings submitted to judges for the exhibit are rejected annually and no more than two are ever accepted from one artist. Paintings by the local artist which have been accepted for the exhibition are *Stone City* which took first prize and sweepstakes for Mr. Wood at the Iowa State Fair; and *American Gothic*, a painting of a house in Eldon, Iowa."[40]

The juries deliberated, and they awarded the top money prize of $2,500 to a marble entitled *The Water Carrier* by Heinz Warncke, a sculptor of the German school who had come to America just after the war. The work is weak and trite, and its style is virtually a copy of that of jury member, William Zorach. It looks to me like a definite fix.

The Logan Medal and $1,500 went to a forgettable portrait of a woman by an artist who was overtly subservient to the style of John Sloan.

The Mr. and Mrs. Frank Logan Prize of $750 went to *Friends* by Jacob Getlar Smith, a pedestrian oil vaguely in the style of Henri Matisse showing two seated young ladies holding hands.[41]

To Grant Wood's utter astonishment and ecstatic wonder, *American Gothic* was awarded the Norman Wait Harris Bronze Medal and $300.

Then the critics weighed in.

The then-hot critic in Chicago was the tall, very elegant Charles E. Bulliett, who wrote for the *Art World* magazine of the *Chicago Evening Post*. His take on the forty-third Annual is such a trite formula of art critics' jargon that I laughed when I read it. Part one, slam American painting in general. Part two, display prejudices about certain styles. Part three, make a local witticism. Part four, single out the Worst Work in the Show. And, finally, part five, make the "discovery," including an art historical reference so arcane that the reader definitely gets the point that Bulliett knows his stuff.

Bulliett's review must not have pleased director Robert Harshe when he said the exhibition was "a very fair presentation of what is normal in the American scene . . . The normalcy is a rather high grade of mediocrity."

Then came the put-down of various styles that he personally didn't approve of.

"The floods of 'Modernism' have washed these American shores, as did erstwhile the floods of French 'Impressionism,' and the high waters are now on the ebb. Most of our better American painters by now have learned as much from Cézanne as the former American generation learned from Claude Monet—and no more. That is to say, we all know now that substance and solidity are necessary ingredients in good painting—just as thirty and twenty and ten years ago we all knew that they were not. The gospel of Cézanne has been accepted in toto by all our more progressive painters—

and even the 'conservatives' have grudgingly given way, producing something that is akin.

"Cézanne and his disciples are the main inspiration. There is little or nothing of the 'abstract' or the realistic developments out of the abstract that are now regnant in Paris and Berlin and Rome. We are picture makers this side of the Atlantic, and we heaved a sigh of relief when the tide of 'Cubism' began to go out. Like our conservative critics, our American painters believed 'Cubism' a failure, and so were happy of the chance to ignore it . . . 'Cubism' left a strain in art that will take ages to eliminate. It is partly for that reason that our contemporary American art is 'spineless'—that our normalcy, as we have related, is just a high grade of mediocrity."

The worst work in the show for Charles Bulliett was Edwin Dickinson's huge *Fossil Hunters*—but it belongs because of the notoriety it attained in the academy exhibition in New York last season from being hung on its side instead of upright, as the artist intended.

"There is now a brass plate affixed to the frame, making impossible such a mistake in hanging—if mistake it was, instead of a 'press stunt,' as has been openly charged. It is a good piece of showmanship to include 'Fossil Hunters' in any American exhibition— and museums, if they want to be up-to-date, must bow occasionally to the imp of the hippodrome."

Then the "discovery" which he alone had made in this overwhelming mediocrity, "a flash of 'inspiration' that makes the visitor glad to be alive in Chicago in 1930, and the biggest 'kick' of the show comes—not out of New York or Woodstock or the effete East, nor even out of Al Capone's jazzed-up realm—but out of Cedar

Rapids, Iowa. The painter is Grant Wood, and he has two pictures *American Gothic* and *Stone City*. Wood approximates more nearly an American Douanier Rousseau than any of the 'primitives' we have heretofor beheld—more nearly than Peter Blume in New York and Pollock in Chicago. Wood is as naive in his outlook as Pollock and as expert in his workmanship as Blume. The Douanier Rousseau was the high genius of 'Modernism' in both respects. Wood's big contribution to the joy of the moment is not that he is a mere imitator of Rousseau, but that, working with American motifs, he gives an American something of the thrill Rousseau, a follower of the little Dutchmen and the primitives of Flanders, gave with French motifs to twentieth-century Frenchmen.

"*American Gothic* depicts a farmer and his wife in front of their simple, gabled farm home, the farmer holding in his hand a pitchfork of 'pattern' carried out in the bosom of his collarless shirt and in the window in the gable of the house. His wife wears an apron with 'pattern' repeated again in the drapery of the window. The picture is worked out with masterly technique—and yet remains quaint, humorous and American."[42]

What Bulliett meant by invoking the name of Henri "Le Douanier" Rousseau remains unknown to me, and I've thought hard about it. He cannot have been comparing the stilted creations of self-taught Rousseau—the French painter who Picasso waggishly dubbed "the last of the great ancient Egyptian painters"—to Grant Wood's penetrating portrait of Nan and Byron. There's nothing in the least comparable in the works of the two artists. Rousseau's people are rough-hewn, wretchedly drawn, third-grade-level

characters. They are in no way alike the impeccably rendered *American Gothic* couple. What Bulliett may have trying to say was that Rousseau's use of pattern and motif was similar to Grant Wood's. In fact, it's not.

Marguerite B. Williams, of the *Chicago Daily News*, was also delighted to find no dread "Cubism" in the show. Artists, she said, seem to have gone elsewhere for inspiration. And, putting her finger straightaway on the pulse, she continued, ". . . it is that meticulous kind of realism practised by the Old Masters that seems most to attract the younger artists. Take Grant Wood, the young Cedar Rapids artist, the discovery of the exhibition. His 'American Gothic,' the prim, suspicious-eyed, small-town couple that stand by the side of the Gothic domicile, is as uncompromising as exposition of solid detail as a Van Eyck or a Ghirlandajo. It is one of the finest records of Americana that has ever been painted."

Hallelujah! An art critic hits one out of the park!

All wasn't sweetness and light with the critics—is it ever? The *Boston Herald*'s art pundit, Walter Prichard Eaton, interpreted *American Gothic* as a banner of Christian fundamentalism. Although Eaton knew nothing about Wood (and, for sure, had never bothered to call Wood), he figured the artist had to have "suffered tortures from these people who could not understand the joy of art within him and tried to crush his soul with their sheer ironbrand of salvation."[43]

American Gothic became the smash hit of the show. Crowds milled around it and ignored the other works. I can understand why. Many times, I have taken a dozen folks into one of the galleries of the Metropolitan, say, one

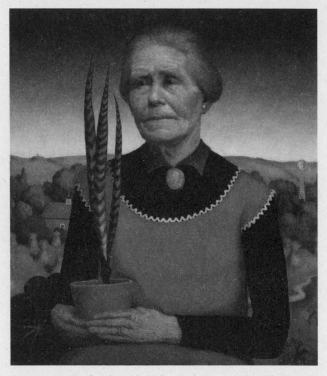

Fig. 10. *Woman With Plants* had been shown at the Chicago Annual exhibition in 1929. Notice the tennis-ball-shaped trees, the cameo at the woman's throat, and the plants. They all reappear in *American Gothic*. *Woman With Plants*, 1929, oil on upsom board, $20^{1}/_{2} \times 17^{7}/_{8}$ inches. Printed with permission by The Cedar Rapids Museum of Art. (Copyright © Estate of Grant Wood/Licensed by VAGA, New York, NY.)

for French eighteenth century, and asked them to give me—in five minutes—which *single* painting they think is the superior one. Invariably, eight or nine out of ten people pick the same piece—which happens to be the one I, too, think is the best. Laymen, even if not steeped in art history, really can spot artistic excellence.

The institute's patrons' club, the Friends of American Art, put up $300 to acquire the painting, which has got to be one of the finest accessions strokes in the history of American museums. Grant Wood was elated, for it was the first time any of his works had been bought for any museum, much less one of such international stature.

Because critic Charles Bulliett had described *American Gothic* as a portrait of a farmer and his wife, controversy bubbled up, setting the stage for unending discussions of whether this is a straightforward portrait of a pair of doughty, honest farm folk or a deliberate satire of same. The controversy, continuing to this day, took something of a toll on Wood's creativity, for never again would he attempt another painting as frank, unsentimental, and honest as *American Gothic*. From the moment the heat began, he started to waffle back and forth as to his reasons for painting the work and what he wanted it to represent.

When the *Des Moines Register* picked up on Bulliett's description, a hundred letters flooded the paper. As the *Chicago Leader* reported the day after Christmas, 1930:

AMERICAN'S PAINTING ROUSES IRE
OF HIS FELLOW IOWANS
Canvas Erroneously Believed to Be Portrait
of Western Farmer

Something of a sensation has been created by Grant Wood's painting. American Gothic, now hanging in the American exhibition at the Art Institute of Chicago. The trouble came because some papers printed the title as an

"*Iowa Farmer and His Wife.*" *The fact is that the picture bears no such title and the artist disclaims any intention of passing it off as such.*

Mr. Wood declared that "All of this criticism would be good fun if it was made from any other angle. I do not claim that the two people painted are farmers. I hate to be misunderstood as I am a loyal Iowan and loved my native state. All that I attempted to do was to paint a picture of a Gothic house and to depict the kind of people I fancied should live in that house."[44]

Mr. Wood, a resident of Cedar Rapids, Iowa, has, it is said, developed a style and an original viewpoint which has caused the critics to hail him as a district addition to the rather slender colony of American artists untouched by foreign influences. His painting not only won the Harris bronze medal with $300, but has been purchased for the permanent collection of the Art Institute.

The magazine *Art Digest*, published out of New York City, picked up on the story in January 1931 and kept the pot boiling:

IOWANS GET MAD

From Chicago comes news of an Iowan tornado stirred up among the good housewives of the state because the press used the words "Iowa farmer and his wife" in connection with Grant Wood's painting American Gothic *which was one of the prize-winners at Chicago's annual. Depicted is a prim middle-aged couple standing before a prim Gothic-looking farmhouse—a grim Puritanical woman and a stern, tight-lipped man with a pitchfork in his right hand.*

> *Indignant Iowans wrote letters to the Art Institute,*
> *they wrote to Iowa papers and they wrote and telephoned*
> *Mr. Wood. They wanted to know "what he meant by*
> *stamping those two prim, stern people as Iowa farmers."*
> *One irate woman called the artist on the telephone and,*
> *according to the Institute's newsletter "used language no*
> *lady, Iowan or otherwise, should use."*
>
> *"Immaculate Primness" and "Puritan Happiness" are*
> *suggested as compromise names for the picture.*

As Wood described the flak, "When the picture was printed in the newspapers, I received a storm of protest from Iowa farm wives because they thought I was caricaturing them. One of them actually threatened over the telephone 'to come over and smash my head.'"

Some of the letters attempted to be witty. Mrs. Earl Robinson of Collins, Iowa, wrote that the "painting should be hung in a cheese factory . . . That woman's face would positively sour milk."[45]

Another writer was offended by the old-fashioned pitchfork: "We, at least, have progressed beyond the three-tined pitchfork stage!"[46]

The painting also was vigorously defended by some Iowans. Grace M. Shields saw "strength, dignity, fortitude, resoluteness, integrity" in the faces of the couple, "the same truth and beauty" she found in some of local poet Jay Sigmund's works. She was correct! For Grant Wood was a friend of Sigmund's, and no doubt had been inspired by some of Sigmund's words on pioneer Iowans—and perhaps vice versa.[47]

Once the Annual was over, traditionally the Art Institute gathered together the best pieces and traveled

them throughout the nation. *American Gothic* was one of the prime pieces of the show and gained great renown— and some notoriety—along the way. After Chicago, the show went to Ann Arbor, Cedar Rapids, the Minneapolis Institute of Arts, San Diego's Fine Arts Gallery, an art gallery in Santa Barbara, and, eventually, the Whitney Museum in New York City.

When it arrived at the Whitney in 1934, some heavyweight eastern critics weighed in with their opinions. Marquis Childs, a midwesterner, thought the painting "is Iowa, grim, bleak, angular, with a touch of humor and a heart of gold."[48]

Christopher Morley, writing in the *Saturday Review*, said the faces "were sad and yet fanatical," and symbols of "what is Right and what is Wrong with America."[49]

For the people who came to gape at *American Gothic*, there were two questions on their minds besides what was right or wrong in the land. Who was this Grant Wood? Where was he going?

9.

WHO WAS GRANT WOOD
AND WHERE DID HIS
ART COME FROM?

What was Grant Wood like? My favorite story is told by his biographer Darrell Garwood.

"He was short and stout and wore a brown, thickly woven suit. His head was large and his hair a reddish-brown color. He wore heavy glasses, his cheekbones were high, and he was inclined to squint. His chin jutted and was deeply cleft. The most peculiar thing about him was that he never stood still but swayed from side to side, resting his weight first on one foot and then the other. He stood there swaying now, studying the picture long after he must have seen everything there was to see. Then he looked at his wristwatch and glanced at Dave Turner. He walked the full length of the room to lay the hammer on a bench, walked back to where Turner was standing, and said calmly: 'I just remembered that I have an appointment

with Mrs. Douglas in Cedar Rapids. I'll have to leave.'
After a pause to let Dave think that over, the artist
added: 'The train is leaving in fifteen minutes.' David
Turner, big, active, and accustomed to dealing with
complicated situations, sized up this one quickly: if the
appointment was with Mrs. Douglas, it was important—
she was one of the wealthiest women in Cedar Rapids;
fifteen minutes might be just time enough to get Grant
through two miles of traffic to the railroad station. So
he grabbed his overcoat and hat, dogtrotted to his
automobile, and had the motor racing by the time
Grant got there. As they swung down Grand Avenue,
Grant remarked: 'My clothes are at the Des Moines
club.' Dave stepped on the gas. It meant more driving
through traffic and a stop at the Des Moines club, but
he still thought he would make the train. He pulled up
in front of the club door and waited while Grant went
for his clothes. The artist had taken off his overcoat
and was actually hurrying a little when he came back
with his suitcase. But as he dropped into the front seat
he said: 'I haven't got any money.' Grant Wood was
extremely deliberate in his speech, even when pressed
by events. He spoke like a schoolboy reading in bad
light, with pauses so that the listener bad constantly to
pick up his words and string them into sentences. 'I-
haven't-got-any-money,' was the way this news came to
Dave, like something relayed to him on a telegraph
wire. He turned around to give Grant a hopeless look,
and then went into action. He had only a few dollars
himself, so he ran into the nearest restaurant and
planted himself in front of the proprietor. 'I'm David
Turner. I run a mortuary in Cedar Rapids and I've got

to have twenty-five dollars at once. Will you give it to me?' The proprietor had never heard of David Turner and wasn't interested in mortuaries or Cedar Rapids, but he did a strange thing. After staring blankly for a moment, he reached into the cash register, pulled out twenty-five dollars, and, with no more security than a 'much obliged' thrown over Dave's shoulder, saw the money out the door. Turner managed to get Grant onto the train as it was pulling out, and came back to his car flushed but feeling that a difficult job had been well done. His face fell when he opened the car door. It was bitter cold, but Grant had forgotten his overcoat. In a pocket of the coat were his heavy glasses, without which he couldn't see much farther than a mole. Such lapses never persuaded the people of Cedar Rapids that Grant Wood was anything less than a genuine artist. It is true there were few who foresaw his later fame, but people felt that he was at least touched with genius, and if he couldn't remember names or appointments, if he swayed from side to side, wore a vacant expression, didn't know what became of his money, or doggedly insisted on something, that didn't make sense that only went to prove it."[50]

Wood's father, Maryville (pronounced: Mur-vil) Wood, married his mother, Hattie Weaver, on January 6, 1886. He was thirty; she twenty-eight. They lived in the tiny community of Anamosa, thirty miles to the southwest of Cedar Rapids, on a farm of a little more than fifty acres. Life on the farm was tough but not hardscrabble. There were no hardships, no pressing financial worries, no severe droughts or destructive tornadoes. Four children were born over a period of

thirteen years: Frank at the end of 1890, Grant in 1891, Jack in 1893, and Nan in 1899.

One of Grant's most vivid memories is sitting on a fence close to the barn, watching his father hook up the team for plowing. Once his father had gone out the gate to the fields, the boy would race into the kitchen to get a charred stick from his mother for drawing on cardboard or wrapping paper.

He'd observe and then draw every conceivable thing on the farm—the house, the barn, the animals, especially the chickens and roosters. By the age of eight, he had portrayed them doing everything they do—clucking, crowing, fighting, laying eggs, sleeping, or just scratching around.[51]

Grant made a list of the birds he'd seen on the farm and sent it to the local newspaper, the *Anamosa Eureka*, which published a note that barely credits the surprising act: "Master Grant Wood, only ten years of age, reports that he has found 55 varieties of birds in this neighborhood. His communication on this subject is very interesting and shows that he is an observing, thoughtful, wide-awake boy."[52]

Maryville Wood was a taciturn man who favored the sciences and history. He was accustomed to reading long passages to the children from *The Decline and Fall of the Roman Empire* and such novels as *The Deerslayer* by James Fenimore Cooper. Maryville was not an especially religious sort. He favored discipline, but young Grant wasn't thwacked or muscled around in any way. Although the elder Wood expressed little interest in art—he refused to allow *Grimm's Fairy Tales* to be read at home because they weren't "real"—he

never objected to his son's constant drawing. When Hattie said she was convinced her son would become an artist, Maryville didn't object.

On March 11, 1901, Maryville Wood died of heart failure, and the family sold the farm and moved to Cedar Rapids, where Hattie's family lived. And that's when money began to become increasingly tighter.

Grant drew more than ever, and in the eighth grade entered a work in a statewide contest organized by the Crayola crayon company, which had just launched eight—count them!—eight colors. He won one of the three first prizes with a study of a cluster of oak leaves.

Grant's closest friend at the Washington High School was another budding artist, Marvin Cone. The pair became the unofficial artists for the school and got into everything artistic, specializing in the making of stage sets, some of which were quite ambitious. The Wood-Cone duo designed and constructed an elaborate section of the *Mayflower* for the play *Priscilla*, that some said should have been launched it looked so seaworthy.

The boys also worked at the Cedar Rapids Art Association, which had a gallery over the public library, and that's where Grant began to pore through art books, becoming particularly taken by the works of the Renaissance and the late Northern Gothic artists. He seems to have had a phenomenal visual memory, and years after seeing a painting he could describe it in detail. To earn extra cash, Wood slept in the gallery from time to time, acting as amateur night watchman.

Wood and Cone experimented with making "death" masks of each other by pouring plaster over their faces

and using soda straws to breathe. Both almost suffocated. Once, a sizable chunk of Wood's red hair— he called the shade "pink"—was torn out by the roots. He laughed it off, calling it "suffering for my art."[53]

Wood was a so-so student who would never have gone on to college, although he became extremely well read, and was acquainted with some famous authors, including William Shirer, McKinlay Kantor, Robert Frost, and Carl Sandburg. His only triumph in school was in manual training—there were no art classes per se. About the only "instruction" he received in art in high school was of a bizarre nature: as the tale goes, when a teacher saw one of his watercolors with its solid lines and colors, she held it under a running faucet, explaining that real artists used broken lines, and tried to attain the blurring effect of atmosphere.[54]

In essence, Wood was a self-taught artist. His school was trial and error. He read avidly about art and how to create it. In his teens, he devoured a design course by the brilliant tile maker and teacher Ernest A. Batchelder, which ran in Gustav Stickley's monthly *Craftsman* magazine. He also enrolled in Batchelder's correspondence course.

Following Batchelder's instructions, Wood bought all his tools and materials—drawing board, engineer's ruled paper, watercolors, brushes, and India ink. The day the *Craftsman* hit the local newsstand, Grant was there waiting to grab it.

Ernest Batchelder, a missionary of the British Arts and Crafts movement, stressed the abstract beauty of Japanese art, and how to build upon principles of decoration rather than mere imitation. He emphatically

underscored the difference between representation and design—representation was the recording of observed facts, design the arrangement of lines or masses in an orderly way for the sake of their decorative value. Wood took it to heart.

The same night he graduated from high school, in June 1910, and at the age of nineteen, with only forty dollars in his pocket, Grant Wood caught a train to Minneapolis to attend the school of design, handicraft, and normal art, called the Handicraft Guild. Batchelder was a visiting instructor there that summer, and for the young, impressionable Iowan it must have been like meeting Leonardo da Vinci.

Wood spent the following summer at the guild, but this time Batchelder wasn't teaching. In the years, he learned how to make jewelry, copperware, ornamental iron fixtures, and furniture.

After that, Wood attended a life-drawing class at the University of Iowa under a French-trained academic. From 1913 to 1916, he lived in Chicago, where he took a few night classes, drawing live models at the Art Institute. In Chicago, he worked in a silversmith's shop, and he briefly branched out on his own making jewelry, a small enterprise that, sadly, went out of business.

When his mother Hattie suffered financial reverses and had to sell the family home in 1916, Grant quickly returned to Cedar Rapids. An accomplished carpenter, he did the most amazing thing: he built a shack with his own hands, with few or no amenities, just before a terrible winter ravaged Iowa. There, Grant, his sister Nan, and his mother managed to survive. Afterward, with the help

of a friend, he built two bungalows in Kenwood Park, and the Woods moved into one of them. Grant's mother lived with him for the rest of her life. The relationship was so enduring that one Cedar Rapids resident commented that Grant was obsessed with Hattie.

By the late 1910s, Wood had developed an easygoing, soft, appropriately "blurry" painting style. He produced dozens of still lifes and landscapes, which today are scattered throughout dozens of homes in Cedar Rapids and the surrounding area.

Wood joined the army in 1918, and he was sent to Washington, D.C., to design camouflage for artillery batteries. There, he augmented his meager soldier's pay by making pencil drawings of his fellow troopers. They are clearly the efforts of a self-taught, struggling artist.

In 1919, Wood came back to Cedar Rapids, and, despite no training and a meager record as a teacher, was hired by a prescient principal to teach art in the Cedar Rapids public school system. He did so until 1925, when he quit to try to become a full-time artist.

Grant Wood's exploits as teacher became something of a local legend. Often late to work, sometimes not showing up at all, he nevertheless was judged as one of the best teachers in the school, at least as far as art was concerned. He excelled at inventing new ways of getting the passion and mystery of art across to his youthful charges, and he was revered by them no doubt because of his freewheeling ways. One amusing project was to help some students design a medieval-looking bench to place outside the principal's office, the back of which includes the inscription in high relief: THE WAY OF THE TRANSGRESSOR IS HARD.

For the students, his class must have been a thrilling, ever-changing experience. They were asked to make hosts of marvelously nutty things ranging from the transgressor's bench to lampshades made out of waxed butcher paper and flattened tin-can tiles perforated with designs, linoleum-block cards, and illustrations for the class yearbook.

Wood led a gang-sized group of forty-five students in creating what he christened the "Imagination Isles." He explained to them that he wanted them to paint their own images of an enchanted island where a visitor might be greeted by "brilliantly colored trees of shapes unknown to science, silhouetted against purple mountains. Mountains whose snowcapped peaks pierce the saffron skies. Fantastic tropical plants with luscious fruits and flowers in amazing profusion wait only your coming and choosing."[55] Then, after a warning that no corporal but only spiritual body could visit these isles, Wood lectured about the ill effects of materialism on the imagination: "Almost all of us have some dream power in our childhood, but without encouragement it leaves us and then we become bored and tired and ordinary. In most of our studies we deal only with material things or in ideas that are materialistic. We are carefully coached in the most modern and efficient ways of making our bodies comfortable and we become so busy about getting ourselves all nicely placed that we are apt to forget the dream spirit that is born in all of us. Then someday when we are physically comfortable we remember dimly a distant land we used to visit in our youth. We try to go again but we cannot find the way. Our imagination

75

machinery is withered just as our legs or arms might wither if we forget for years and years to use them."

To escape the withering influences, Wood advised the students to exercise their imaginations through travel, literature, music, and art. He linked the food served in the school cafeteria to what he wanted the students to make up by describing them as products of the Imagination Isles. Baked potatoes were to be imagined as "the succulent seed-vessels of the magical mingo tree," while boiled cabbage was transformed into "the crisp and tender leaf of the Clishy-Clashy vine." Finally, the creamed peas dissolved into "pellets of foam driven by playful waves upon a phantom beach."[56]

Charged up, the students decorated a paper roll eighteen inches wide and no less than one hundred and fifty feet long. Every three or four feet, a different student would paint a special imaginary landscape, with Clishy-Clashy whatever and saffron skies and towering mountains. When completed, the extensive frieze was wound around some nail kegs and then unrolled in the cafeteria as a kind of slow-motion movie. House lights dimmed, music went ta-da, and as each island came into view the student responsible for it read a script, prepared by Wood, which urged the onlookers to join in the imaginary island tour. The gist was what Wood had already told the students, that only the spirit could come to the enchanted isles, and that only artists were "trained to dwell" there. Ordinary folk needed the artist to take them to this blessed, spiritual realm. All materialistic people whose imaginations had become "withered" were "mental shut-ins" who could be freed

again only by true artists. The show was, as they used to say in the Midwest, "a hoot."[57]

Wood's puckish sense of humor entranced not only his students but the citizens of Cedar Rapids. He retrofitted his old car with a turn signal shaped like a left hand with a pointing finger. He'd crank up the hand before a left turn, and people chattered about the thing. They chattered even more when it became fiercely cold and Wood painted a glove on the hand. He enjoyed making wild costumes for the elaborate masquerade parties so much in vogue in the 1920s. Once, he came as a giant fish, and another time as Cupid with erratically flapping wings. He also planted huge yeti-like footprints coming from a small swamp near his bungalow to the entrance.

In 1920, Grant Wood took the summer off to go to Paris with fellow artist Marvin Cone, and spent most of the time outdoors—no matter what the weather happened to be—painting small oils. Those that survived show a soft, appealing style of emphatic forms and fairly heavy layers of paint of bright contrasting colors. He seems to be more interested in form, for his atmospheric effects are virtually nil.

In the next couple of years, Wood gradually made a name for himself in Cedar Rapids as an artist who could do anything—carpentry, house design, painting murals and signs, even creating occasional junk sculpture. His style changed according to the job; it could be art nouveau or neoclassic or impressionistic, depending on the task.

One of the memorable pieces—which hangs today in the Cedars Rapids Museum of Art—is an outdoor

sign, oil on canvas, some two feet by seven feet, created for a realtor to display under a canopy, beautifully lighted, in front of a model home.

The work, entitled *Adoration of the Home*, in academic, classical style, shows Cedars Rapids symbolized in a young mother reading a book to a naked child on her lap while holding aloft the model home itself. In a friezelike arrangement, with the skyline of downtown Cedar Rapids as a backdrop, you see figures representing agriculture and building—a farmer with livestock, his wife with sheaves of corn and wheat, construction workers, a hod carrier, a carpenter, a steelworker, all adoringly in awe of the glistening home—while Mercury, the god of commerce (and trickery), approaches from stage right and blesses the event. It sounds a bit stiff but actually isn't so bad, except for its lack of original style—it has no artistic voice.

In 1923–24, Grant Wood took a two-year sabbatical to go to Europe. In the fall, he studied at the Academie Julian in Paris, which was frequented by many foreign art students. There, he attended some life classes, and he further honed his impressionistic style. He spent the rest of his time working outdoors. In the mid-twenties, Paris was a hotbed of radical art, where Picasso and Braque were redefining virtually everything. But Wood hadn't the slightest interest in the new, modern wave, although one must presume that he did pick up a few pointers from the "wild beasts."

During the winter, Wood traveled through Florence and Rome to Sorrento. Since we know he went to every art museum in sight, we can reasonably assume he

didn't bypass the Uffizi. There, he must have seen the great treasures of the Renaissance—the Botticellis and the Pieros—and no doubt, too, that monumental triptych, *Adoration of the Magi*, painted in 1475 by the Fleming Hugo van der Goes for the Bruges Medici banker Tomasso Portinari. The painting had gone on view after restoration a year before, and it was the talk of the town. Wood, despite his utter lack of Italian, must have heard about the masterpiece. Its stark realism, those long-faced, partly stylized and partly naturalistic figures, and the exceptional clarity of detail must have impressed him. He wouldn't use any of this immediately in his own work, but when he came to creating *American Gothic* the influence of *Adoration of the Magi* seems undeniable.

Upon his return from Europe, Grant Wood enjoyed a great stroke of luck. David Turner, the mortician featured in the Garwood anecdote at the beginning of this chapter, was a sincere and active Cedar Rapids booster, and was one of Wood's steadfast patrons, even acting as his agent part-time. He was ten years older than Grant and had known him since he was a youngster, having grown up near the Woods. A natural "eye," he saw early on a highly talented artist, and he assiduously collected Wood's work. Turner commissioned Wood to decorate his new funeral parlor in downtown Cedar Rapids, and told him he also could fix up the brick stables in back and make himself a studio and live there rent-free. Wood delightedly agreed and started working on the place, which he dubbed 5 Turner Alley. He moved in with his mother in 1924, and stayed until 1935.[58]

The upstairs quarters at 5 Turner Alley were minuscule, and what Wood managed to do with the space amazed everyone who came to visit. With students as helpers, he turned the intimate, low-ceilinged, dormered apartment—hardly big enough for two people—into a multiuse living and gallery space, which at times even included a small theater. This living-working area, which was recently restored[59] was looked upon by Cedar Rapids citizens—for word of the transformation had been spread far and wide by David Turner—as something of an act of interior decorating genius.

The walls were covered with a specially colored plaster. Cupboard doors were made of old overalls hardened with plaster and given a leather finish. Most of the furniture was built in, making the interior look like an Arts and Crafts, upscale but funky luxury yacht. The dining table folded behind cabinets, the drawer beds slid out of sight. Recessing the bathtub in the floor allowed enough room for a stand-up shower. Wood wanted to tile the floor, but the ceiling downstairs wasn't strong enough to support it, so he invented a tool, based upon his mother's cabbage chopper, that grouted out the wood floor into squares, which he and his assistants then painted to look like genuine tiles. The chef d'oeuvre of this singular aerie was the front door: Wood painted its glass panel to look like an old clock, with a movable hand he could point to the hour he'd be back or one of three messages—GRANT WOOD, it read across its face, IS OUT OF TOWN, IS TAKING A BATH, or IS HAVING A PARTY.[60]

Cedar Rapids in the 1920s was known throughout Iowa as being culturally aware, and, if not into the radical new European movements, at least sympathetic to modernism. There was that Art Association gallery above the main library, where Wood had slept when working as part-time night watchman. And in 1928, "an experimental art station" was established by the American Federation of the Arts, and funded by the Carnegie Foundation. The Little Gallery, as it was known, started up shortly after Wood returned from Germany. Its director, Edward Rowan, who had asked Wood to come to Eldon, where he saw the now-famous house, became an enormous influence on Wood. Rowan had recently graduated from Harvard's prestigious master's in the fine arts program and he was there to run the operation, staying until the end of 1933. He saw his mission as trying to make contemporary art benefit contemporary life. Eventually housed in a lavish Victorian house, the Palmer House, the Little Gallery conducted classes, staged special exhibitions, exhibited local writers' manuscripts, and made rooms available for local artists to show off their work.

Edward Rowan became Grant Wood's Pied Piper, urging him to submit works to the Iowa State Fair and the Chicago Annual. While the gallery never mounted shows of the radical French artists, the library had an abundance of books available on all aspects of the modernism movement, and one can be sure that Grant devoured everything in sight.

In 1925, David Turner persuaded Wood to quit teaching and devote himself to painting and interior decorating. Turner talked Wood up, and secured a host

of commissions for him. The funeral parlor became Wood's gallery, showing many of his landscapes and still lifes. He seems to have become all the rage in the interior design and home-building world in Cedar Rapids. With a contractor buddy, he designed and built neocolonial homes, a shingle-style château, and a one-of-a-kind house based upon nineteenth-century Iowan archi-tecture. He would also redecorate older homes in a wide variety of styles, ranging from neoclassic to Tudor. He was exacting, meticulous, amusing to be with, and not too expensive—therefore, a much sought-after artist.

It was in 1927 when Grant Wood did his first commissioned portrait, an oil of the infant daughter of the Stamats family, for whom he was designing and building a fine neocolonial brick home with all his special trimmings inside. The portrait of little Sally is a decent likeness, and isn't sweet or cloying. The jokester in Wood shows up in the block the child clutches, with its relief-carved letter S for Sally Stamats. This portrait engendered several others, although he seemed to grumble about having to do them.

One of the best of his pre–*American Gothic* portraits is, in a sense, a direct prefiguration to *Gothic*'s hard-edged, frank, direct feeling. It's a study of David Turner's eighty-four-year-old father, John B., who is portrayed clad in his forbidding black three-piece suit and black necktie in front of an 1869 map of Linn County, Iowa, where he had settled in the 1880s. Wood lovingly executed a trompe l'oeil tour de force on the right side of the map with sepia engravings of village scenes. There's a black line in the county map

that crosses behind the head of the sitter, which is the railroad that John B. Turner worked for a number of years. The work is entitled *John B. Turner, Pioneer*. When he saw it when it was almost completed, the old man is said to have muttered joshingly, "Two old maps."

John B. Turner, Pioneer was created in either 1928 or 1930—there are two dates on it. Just exactly when the work was finished is a bit cloudy. It seems to have been started in 1928, and signed and dated and framed in a rectangular frame that same year, but after Wood returned from Munich in 1929 it was redone. He readjusted some elements in the painting—no one seems to know which ones—to conform to his desire for harder edges and more solid areas of color. Then, in 1930, he placed the work in an oval frame, perhaps to emphasize the shape of the sitter's head.

The clarity of drawing, the compelling nature of the face, the startling eyes with their heavy pouches, the distinct wattles of age on the neck are all definite signs of a striking new realism in Wood's works. Gone are the art nouveau cutenesses, the fluffy, painterly, faux-impressionistic brushstrokes, the aura of things slightly out of focus. This is the frank and pleasingly unvarnished study of a resilient, hard-bitten, yet not unfunny, old pioneer who, one feels, might still pack up his family and goods in a Conestoga wagon and "Go west, young man." This is the very essence of Grant Wood's concept of the frontier myth, heritage, and hope. *John B. Turner, Pioneer* can best be thought of as a transition between his soft works and the brief, shining period of hard works, and it is, without doubt, a landmark in the birth of his new style and his

growing focus on his homeland surroundings, history, and spirit. I personally think Wood began the work in 1928, then radically reworked it in 1930 just before *American Gothic*.

Another goad for Wood to concentrate on his homeland came from Cedar Rapids poet (and insurance salesman) Jay Sigmund. Gripped by rural Iowan roots and the pioneers who braved daunting challenges to settle the land and farm it, Sigmund believed that art should come from where the artist had been born and bred. Among his many poems was one praising Wood's impressionistic paintings in which Sigmund characterized him as a "new son dreaming on the plain."[61] The summer before Grant went to Munich, Sigmund took him on a tour of his hometown of Waubeck, a hamlet on the Wapsipinicon River not far from Anamosa. Wood was so excited that he spent some weeks in the town in 1927 and 1928. Interestingly enough, he met some of the farmers in Waubeck, who had clung to their nineteenth-century customs and way of life. He met, in fact, the real *American Gothic*.

How Grant Wood got to Munich involves his only major commission, a large stained-glass window—he truly was a jack-of-all-trades. It was for the Veterans Memorial Building in Cedar Rapids. It is a tall, imposing, neoclassic pile of considerable distinction and honor, with a great, inviting arched entrance portal flanked by two wings. The core structure is embellished by a lofty portico from the fifth to the seventh floors. At the summit, there's a replica of the Tomb of the Unknown Soldier, which, when sumptuously lighted at night, casts a heroic glow upon the surrounding city.

The structure is both a graceful, energetic mixture of the Beaux Arts and a sleek, skyscraper look.

Back then, the Veterans Memorial Building was the tallest structure in town, and it housed the heart of Cedar Rapids's community spirit, which was good government, bountiful crops, healthy trade, culture, and love for America. The town hall was there. So was the chamber of commerce. So, too, a source of pride of the city, a spacious auditorium, with a fabulous organ, where the city fathers hoped the citizenry would congregate and sing hymns and patriotic songs, "America the Beautiful" and "Onward, Christian Soldiers." Which they did.

The great entry hall was dominated by a large window that fairly cried out for some grand decorative scheme. It was decided that would be a stained-glass window (appropriate for this shining new cathedral of commerce, culture, and nationalism), commemorating the war dead of the country's six wars.

There seems to have been no thought of anyone other than local art tyro Grant Wood on the part of the veterans committee veterans to design and supervise the construction of the massive, twenty-four-foot-high window. Wood wasted no words in his application, reminding one and all that he was "both a Legion and a local man." He gently warned that he was pretty sure that "no outside man could put into the window the work and devotion that I will." The committee, against its own bylaws, never bothered soliciting any other bids. For once, an art committee made the right move.

Wood made a highly finished study, "Preliminary Sketch for Idea and Color," where the commemorative

plaque eventually would be. When the study was approved with some minor changes, he developed a full-scale drawing. The image (Fig. 11, page 88) is dominated by the female personification of the Republic, holding the palm of martyrdom in her right hand and the wreath of victory in her left, floating over six soldiers wearing uniforms that identify conflicts extending from the Revolutionary War to the "war to end all wars."

The eighteen-foot-tall allegorical figure is rendered in a mixture of styles—art nouveau, neoclassic, and Beaux Arts—and looks like a Greek column suspended in luxurious cumulus clouds with a radiant azure sky at the pinnacle. The poses of the six soldiers vary just enough to add a subtle degree of movement to the ensemble. As a war memorial, the work is dignified, restrained, and effective. But as a work of art, it is timid and *retardataire*. The local reaction to it would be so-so, and the promised gala opening was never held, to Wood's bitter disappointment. The lack of recognition would have a singular effect on his subsequent work.[62]

Being the supermeticulous craftsman he was, Wood rejected the efforts of a St. Louis window company to produce the glass and suggested that it be produced in the Emil Frei works of Munich, which was about the only workshop still working in the late medieval manner. The committee agreed. Later on, nationalistic groups, especially the Daughters of the American Revolution, objected bitterly to the use of a "Boche" company for something as sacred as an American war memorial. (Wood eventually would strike back at those "daughters.")

He devoted months, along with his young assistant, Arnold Pyle, to the full-scale mock-up of the window. The drawing measured twenty-four feet by twenty feet, and was drawn on fifty-eight sheets of paper mounted on board. Wood toiled tirelessly to modify the work so that all parts of the window would display proper perspective when viewed from below. It seems logical to me that the arduous effort involved with these panels, which had to be fitted together in the most precise way, was a factor in Wood's change of style, for this complicated undertaking was a far cry from his earlier, small, loosely assembled oils. With the window, he had to be spot-on with measurements, he had to wrestle with a complex grid to get the transference right, and he had to emphasize strong lines and primary colors, which were flat and patterned, to get the design to work from a distance. So many of these qualities eventually would appear in *American Gothic.*

The trip to Munich, which lasted only from September to December 1928, further changed Grant Wood's artistic frame of mind. He had problems with the German craftsmen, particularly with the drawing of the faces of Republic and the six soldiers. They were used to fabricating pseudo-medieval images when repairing war-destroyed windows, so they envisioned the six soldiers as pseudo-medieval saints. Wood jumped in, learned the technique of painting glass with iron-oxide stain, and tried hard to give his soldiers a twentieth-century American look. Although they turned out a lot better than the insipid saints, their expressions are still somewhat bland.

Fig. 11. Grant Wood's trip to Munich was chiefly funded by his one major commission, the twenty-four-foot high stained-glass window for the Veterans Memorial Building in Cedar Rapids. (Printed with permission from the Cedar Rapids Museum of Art.)

Grant Wood's fascination with such late Northern Gothic and Renaissance masters as Memling, Dürer, and Hans Holbein was ignited by seeing spectacular works in the flesh at the Alte Pinakothek in Munich, the city's world-class gallery, and at the Nuremberg picture gallery. We know he visited both treasure-houses because he talked about Munich in interviews, and he brought back several oil study views of Nuremberg.

His favorite work at the Alte Pinakothek was the radiant diptych of the Madonna surrounded by a choir of angels on the left panel, and on the right Saint Michael gently shoving forward the man who had commissioned work, who is kneeling in prayer. (Fig. 5, page 44). This is work in which Michael's armor reflects the Madonna, and was, I think, borrowed by Wood for *American Gothic*, where the pitchfork is "reflected" in the overalls. He is a visual pun, like the S in the portrait of Sally Stamats. And the face of the Madonna just so happens to be a dead ringer for Nan Wood's in *American Gothic*.

In an interview given in the spring of 1932,[63] Grant Wood spoke of his adoration of Memling and other late Northern Gothic and Northern Renaissance masters. He stressed how he'd always "assiduously" studied Hans Memling, and that the opportunity to see Memling's work many times in the original was a powerful force in changing his painterly style to one of uncompromising directness and realism. Wood stated that he was drawn especially to the "rationalism" of the Northern masters, and was impressed by their ways of "designing cohesive compositions overlaid with a multitude of details."[64] He was also taken by their

"storytelling pictures." But then he warned against storytelling, fearing that the works would become overly illustrative and dependent on their titles to be understood.

Grant Wood probably wasn't aware of the plethora of symbols in the Northern Renaissance works (and various artists' knowledge of Sanskrit), but he did appreciate how these masters so effectively used the decorative elements of their own time with historical subjects. (Northern painters depicted biblical scenes with all the players in fifteenth-century dress.) Wood said that after his intense scrutiny of Memling and the others, he intended to have "decorative adventures" in his new work. "The lovely apparel and accessories of the Gothic period appealed to me so vitally that I longed to see pictorial and decorative possibilities in our contemporary clothes and articles."

A number of art historians believe that in Munich Wood also saw the works of German contemporaries who were into a hard-edged realism—"*Die Neue Sachlichkeit,*" or the New Objectivity—and was deeply influenced by them. The likes of Otto Dix, George Schrimp, Erich Wegner, and Christian Schad. Yet while there are superficial similarities in style—one-point perspective, sharp delineation and modulation of form, stark delineation of color—it is frankly absurd to think that the Iowan hometown boy would have fallen for the dour, *Cabaret*-like cynicism and lugubrious anatomical distortions of the New Objectivity crowd.[65] In fact, Wood said that he'd gone to Munich's contemporary exhibition hall, the *Glas Haus*, and didn't much like the pictures. The surface similarities

are more likely explained by the fact that both the German realists and Grant Wood had fallen in love with the late Northern Gothic masters' work.

Upon his return to Cedar Rapids, and once the stained-glass window was installed, Wood suffered knocks about the Boche fabrication, and some criticism about the general weakness of the piece. The art committee fled; they didn't support their boy, refusing to have an unveiling, and even failing to afix the bronze plaque at the foot of the window. Wood, extremely sensitive to criticism, especially at this time in his career when he knew he'd flattened out, decided to go for broke and drastically changed course.

He painted some intriguing still lifes, with patterned shadows, strong linear outlines, and bold, flat colors. He did the portrait of his mother mentioned earlier, *Woman With Plants* (Fig. 10, page 62), which looks like a modern Memling portrait in its use of tight drawing, smooth glazes, clothing reduced to intricate patterns, and placement of the figure looking slightly to the left. His mother holds a snake plant, like some religious artifact being held in a Memling portrait. What delighted the locals was that the background, with its corn shocks and rolling hills and red barn, was quintessential Iowa.

He followed *Woman With Plants* with a portrait of his assistant Arnold Pyle, *Arnold Comes of Age* (Fig. 12, page 92), where we see the new style emerging further. It is still slightly soft and painterly, but the drawing is approaching the crispness of Memling.

Urged on by Ed Rowan, Grant Wood submitted *Woman With Plants* to the Chicago Art Institute's

Fig. 12. *Arnold Comes of Age* (portrait of Arnold Pyle), 1930, oil on board, 26³/₄ × 23 inches. Sheldon Memorial Art Gallery and Sculpture Garden, University of Nebraska-Lincoln, NAA-Nebraska Art Association Collection. (Copyright © Estate of Grant Wood/licensed by VAGA, New York, NY.)

Annual of 1929 and it was accepted. Rowan praised the portrait in his newspaper column, and made a pitch to Wood to cast aside his former subject matter, and recognize that it was in the heartland of Iowa, not Europe, where he should go for inspiration. He urged Wood to paint local people, ". . . each sitter patterned, as it were, against that phase of life in Iowa which has gone into the making of that sitter's individual history."[66]

And then Grant Wood went to Eldon, Iowa, spotted that cardboardy frame house, so typical of Iowa, immediately conceived of having the Gothic face of Dr. Byron H. McKeeby as a dreamlike echo of the golden days of the nineteenth century, and created his unforgettable icon of the enduring fortitude of rural America.

10.

FAME

It seemed that no one wanted to see anything in the Chicago Annual but *American Gothic*. Despite the fact that Wood's $300 prize was only fourth place, and a fraction of the winner's bounty of $2,500, some newspapers heralded, ". . . unknown Midwest artist becomes rich." He was called the "Christopher Columbus of American art" for bringing a fresh and very heartland style to the country—one that was preferable to the warped stuff from Europe. Rotogravures published the image throughout the land. The mild controversies surrounding *American Gothic* helped keep the pot of fame boiling. Gradually, Grant Wood became a celebrity.

The word got out abroad as well. In 1931, the Frankfurt illustrated newspaper, *Das Illustrierte Blatt*, published *Stone City* on its March 19, 1931, front page, headlined, *"Neue Sachlichkeit in Amerika"* ("The

New Objectivity in America"). The article suggested that Grant Wood had lifted many of his stylistic features from the styles of that 1920s group.

Gertrude Stein, the staunch supporter of the European avant-garde, was quoted in the Iowan newspaper the *Montrose Mirror* on July 17, 1934, saying, "We should fear Grant Wood. Every artist and every school of artists should be afraid of him for his devastating satire . . . He is not only a satirical artist, but one who has a wonderful detachment from life in general—a necessity for creating the best of art."[67]

Caught up in the publicity, Wood soon became an evangelist for his newfound style. He said he regretted the years "spent searching for tumble-down houses that looked 'Europy,'"[68] rather than seeing the artistic possibilities of "cardboardy frame houses on Iowa farms." To make the point that he was a heartland boy, virtually all his official portrait photos will show him wearing overalls—just like the farmer in *American Gothic*. He dismissed his former impressionistic work as "wrist work." He boasted that his fresh and distinctly American style borrowed not from Europe but from indigenously American things like Sears Roebuck catalogues, Currier and Ives prints, handmade quilts, frontier photographs, family albums, and old-fashioned country atlases and maps.[69]

In the spring of 1931, Wood addressed the fourth annual regional conference of the American Federation of the Arts in Kansas City, and presented his personal, highly condensed summary of the history of American painting, and then described the new style that would resuscitate it—his style.

The first wave of modern art in America had been the Mission style, or the Arts and Crafts movement, and it had nudged aside the sentimental and stodgy manifestations of Victorian art. It generated a refreshing simplicity. Sadly, it didn't last. Then, European modernism pushed indigenous American art aside, giving artists "a new force, a new drive and a lot of valuable tools."[70] Modernism, Wood claimed, showed artists how to abstract their forms, and choose the decorative over the literal. Unfortunately, American artists got bogged down imitating this modern style, and never invented a style of their own. Now, in the 1930s, Wood believed painters in the Midwest—himself especially—had created a new, truly American school of painting, following in the footsteps of regional writers who paved the way.

Grant Wood preached that without becoming provincial or primitive, the contemporary American artist could follow his example and develop an independent style by sticking to "literary, storytelling, illustrational pictures." The style, outspokenly conservative and therefore appropriate for the conservative Midwest, came to be known as regionalism. "The story of American life of this period can be told in a very realistic manner, employing sympathy, humor, irony or caustic criticism at the will of the pointer, and yet have decorative qualities that will make it classify not as an illustration but as a work of fine art with the possibilities of living through the ages."[71]

Wood knew well that recognizable subject matter was anathema in avant-garde circles, being considered illustration only. He claimed painters could avoid the

label if they superimposed modern decorative and abstract design onto recognizable subject matter. Then they would never be accused of creating "merely tinted photographs."

Although Wood asserted that *American Gothic* and its broad acceptance had simultaneously freed him from the bonds of Europe and spurred him on to pursue the hard-edged, realistic style exemplified in the painting, in fact it hadn't. Stricken by the criticism, pallid though it was, he backed off. He would never create anything else as forceful as *American Gothic*, except perhaps for one work. None of his later paintings would demonstrate the same bite, clarity, and daring. After *American Gothic*, he became a kind of clever—and artistically hypocritical—superillustrator, honing a coy and sentimental style with at times cloying subject matter.

Grant Wood began to backpedal on what he had intended *American Gothic* to mean. A letter he wrote in 1941 to a woman in Idaho sums up his new feelings:

Dear Mrs. Sudduth,

I enjoyed your reactions to American Gothic *very much. The persons in the painting, as I imagined them, are small-town folks, rather than farmers. Papa runs the local bank or perhaps the lumberyard. He is prominent in the church and possibly preaches occasionally. In the evening, he comes home from work, takes off his collar, slips on overalls and an old coat, and goes to the barn to hay the cow. The prim*

lady with him is his grown-up daughter. Needless to say, she is very self-righteous like her father. I let the lock of hair escape to show that she was, after all, human.

These particulars, of course, don't really matter. What does matter is whether or not these faces are true to American life and reveal something about it. It seemed to me that there was a significant relationship between the people and the false Gothic house with its ecclesiastical window.

Incidentally, I did not intend this painting as a satire. I endeavored to paint these people as they existed in the life I know. It seems to me they are basically solid and good people. But I don't feel that one gets at this fact better by denying their faults and fanaticism.

In general, I have found, the people who resent the painting are those who feel that they themselves resemble the portrayals.[72]

The tough, honest farmer, who clung to the old ways and old beliefs against the gathering storm of the industrial age, had become Mr. Average Citizen, and the farmer's wife had become his daughter. The gentle satire he infused the image with was now denied completely by him.

Grant Wood's fame got him picked up by a gallery in New York City run by Maynard Walker, a booster of representational art and a demagogical foe of the modernist movement. Once a journalist for a Kansas newspaper, he'd become an art dealer. In 1933, Walker

mounted an exhibition of some thirty-five pieces at the prestigious Art Institute in Kansas City entitled "American Painting Since Whistler." A number of works by Grant Wood were shown, along with work by Thomas Hart Benton and John Steuart Curry.

Maynard Walker talked the show up in midwestern newspapers, and arranged for an interview in the ultraconservative *Art Digest*—the very magazine that had published that determined foe of modernism Charles E. Bulliett's rave review of *American Gothic*.

Walker said forget that crazy stuff from Europe—those wacky cubists and radical German expressionists—here is the true stuff, "real American art . . . which really springs from American soil and seeks to interpret American life." He averred that this style would become America's art future—thank goodness—but only if collectors and museums snapped it up. These works, he affirmed, were indisputably the true and honest American "indigenous art expression."

Walker claimed that the Great Depression had at last exposed the madness of foreign art. The Roaring Twenties and the stock market bubble had blinded Americans to true art. During this flapper age, many collectors had been enticed into seeking only the weird and the sensational. Only the most incomprehensible works had been noticed. Only those works created by some loony, drug addict, or "primitive" or "naive" artist had any chance of success.

But since the crash, things had changed radically. People yearned for real, honest artistic expressions. "The shiploads of rubbish that had just been imported from the School of Paris were found to be just rubbish. The freaks

and the interesting boys . . . have lost caste . . . People have begun to look at pictures with their eyes instead of their ears." In other words, take a look at *my* guys!

The tirade was brought to the attention of Henry Luce, the right-wing founder of *Time* magazine, who green-lighted a 1934 Christmas issue devoted to these "regionalists." The lead article, entitled "U.S. Scene," featured a cover self-portrait by Thomas Hart Benton, and the spreads inside—*Time*'s first ever for art—were lavish, for the magazine had just adopted the four-color printing process. The magazine's circulation was close to half a million at the time, and word spread across America about the new Midwest art feeling, and about Grant Wood.

The unnamed reporter who wrote the article capitalized on the public's misunderstanding about and leeriness toward modern European abstract painting. It was hammered home as "crazy" and "outlandish" for its "arbitrary distortions" in "screaming colors." Why was this sick stuff so much around? the reporter asked. Because the dwindling market for traditional paintings had forced American artists to copy cubism, futurism, dadaism, or surrealism after World War I.

But then, at the end of the 1920s, like the 7th Cavalry riding in from the west, a group of local painters from Missouri, Kansas, and Iowa swept all those useless "introspective abstractions" aside with direct representations of familiar environments and familiar inhabitants.

These painters were "earthy midwesterners" who were "restoring American values through their art, in the face of the outlandish foreign import, modernism."

Time singled out Grant Wood as a leader, stating that he was "a more fervid believer" in developing "regional art," principally because he had started a "regional" art school in Stone City—it would go bust soon after starting up. He also had received Public Works Art (PWA) project money to direct artists in a mural project at a university. And he had plugged a series of art schools throughout the Midwest whose fledgling artists wanted to follow his regional example—painters who, like him, were sick and tired of European modernism.

The nationwide publicity provided by *Time* certainly gave Wood a boost. He was invited to lecture across the country, was invited to soigné dinner parties in New York City, and he sold a ton of paintings to private collectors, such as Edward G. Robinson and John D. Rockefeller, Jr. But it hurt him, too. The avant-garde critics, some of them avowed Marxists who detested Luce and his jingoistic magazine, lashed out against Wood, branding him a rank-and-file illustrator. "Illustrator!"—the foulest curse of all in the art game of the 1930s.

Grant Wood didn't help matters by being photographed in his hokey overalls, or by launching peppery petards against the effete East Coast art establishment. In a Sunday, January 19, 1936, edition of the *New York Herald-Tribune*, a nationally syndicated story appeared in which Wood told the apocryphal story of why he abandoned France and Europe for the Midwest (failing, in the process, to point out that his trips there were short-lived): "I lived in Paris a couple of years myself and grew a very spectacular beard that didn't match my face or my hair,

and read Mencken and was convinced that the Middle West was inhibited and barren . . . I joined a school of painters in Paris after the war who called themselves neo-meditationists. They believed an artist had to wait for inspiration very quietly, and they did most of their waiting at the Cafe du Dome or the Rotunde, with brandy. It was then that I realized that all the really good ideas I'd ever had came to me while I was milking a cow. So I went back to Iowa."[73] He later claimed that his reference to milking was that he liked working with his hands. The chances that Wood ever milked a cow in his life are slim; after all, he did leave the farm at ten years of age.

From then on, Grant Wood was pegged a "hayseed" and an artistic hick by the eastern crowd. What little complimentary press he had received there soon faded away, and the anti-Wood crowd took over. Samuel Kootz, an art historian who made the basic error of believing one style was better than another, a fan of cubism, included Wood in a broadside against all realist painters of the twentieth century. He howled that regionalism was nationalistic, chauvinistic, and thus "an innocent approximation of the Fascist attitude"[74] (overlooking the fact that *"Die Neue Sachlichkeit"* was pre-Nazi, and later thoroughly despised by Hitler's regime).

Several years later H. W. Janson, the writer of America's still-used *Art 101* textbook, wrote a sloppily researched article branding in an unconscionable manner both Grant Wood and Thomas Hart Benton as enemies of modern art comparable to the *Reichskulturkammer* of Nazi Germany, Jacob Rosenberg.[75]

"Regionalism," which was never either a style nor a movement, would become by the mid-thirties a pejorative. By the start of World War II, it would be scoffed at by the smart art folk. They had a point. Regionalism had always been something of a con game, as Benton himself would eventually say: "A play was written and a stage erected for us. Grant Wood became the typical Iowa small-towner, John Curry the typical Kansas farmer, and I just an Ozark hillbilly. We accepted our roles."[76]

Although Wood sometimes called the growing criticism "fun," it is clear to me that he was damaged personally by it. He went on the defensive, which didn't help his cause. In 1935, as a professor of art at the University of Iowa, he published a manifesto, entitled "Revolt Against the City,"[77] that was a cry for artists to free themselves from the dreaded, stultifying European "colonialism." (Janson was also at the university at the time and, needless to say, the two men clashed.)

Until his death in 1942, Grant Wood turned out a spare number of "regionalist" pieces—he worked very slowly, due to his desire to apply the appropriate number of glazes. In 1931, he produced *Appraisal*, a dim work depicting a young, lean, stalwart country woman selling a chicken to an old, fattish, fur-wearing lady from the city who looks as well fed as the chicken she's buying. It's satire with no edge to it. *Appraisal* was followed by *Midnight Ride of Paul Revere*, today in the Metropolitan Museum of Art. This is a frivolous illustration of the legend, which includes, amusingly, cliffs very similar to the ramparts and towers in Wood's favorite work by Hans Memling, even a typically Bava-

rian stepped-roof house—all on the road to Concord. The painting is a chuckle, not much more.

Wood then made a lyrical and fanciful portrait of the birthplace of Herbert Hoover, in West Branch, Iowa, which displays many of the stylistic marks of *Stone City*—the simplified, patterned trees, the unclouded sky, the somewhat precipitous perspective.

In 1931, Wood came close to the genius of *American Gothic* in a little-known oil, today in a private collection: *Victorian Survival*. It is predominately sepia, with subtle touches of color for the face and hands. It was modeled after a tintype of Wood's great-aunt Matilda Peet that he found in one of his family albums. The woman may also reflect his aunt Sarah, who helped educate him as a very young boy, and whose hair, he recalled, was so tightly combed back that it almost distorted her face.

Grant Wood captured the balance between serious portraiture and satire perfectly in this captivating image.

The elderly lady has been posed as if she were standing for one of those long-exposure cameras of the nin-teenth century—although, funnily enough, in the original photograph Matilda is far more relaxed. On the surface, this woman is the very symbol of rectitude, one hand held tightly over the other in her lap, proudly wearing a wedding ring (although Matilda was not married).

However, upon closer inspection, her garb is anything but the widow's weeds of the woman in the photograph, with its abundant lace collar and black shroud. This Matilda wears a blouse with a startlingly low scoop, and she sports a fashionable art deco brooch.

Most amusing of all, however, is the thin black ribbon around her neck. It reminds me of the thinner one worn by the very naked courtesan in Manet's scandalous *Olympia*. (Wood must have known about Manet's painting, because it had been published a goodly number of times in America.) Studying Matilda's hands—in positioning and in posture, the hand with the ring is like Olympia's hand in her lap. Next to this severe and oddly provocative woman sits a long-necked telephone.

Some art historians have interpreted this work as a story of an old-fashioned, repressed Victorian spinster who is set in her ways and feels threatened by the modern phone.[78] I don't think so. I see this as a takeoff on sexual repression. This prim lady, with her low-cut blouse, trendy jewel, and kinky black ribbon, is waiting for the phone to ring, to gossip cruelly about everyone she knows. *Victorian Survival* is a powerful figure study, satire, and mind game all in one.

In 1932, Wood painted *Daughters of Revolution*, representing a trio of thin-lipped, smug dames, with a sepia reproduction of Emanuel Leutze's *Washington Crossing the Delaware* on the wall behind them (Fig. 13, page 107). Wood said that this was his only deliberate satire. He did it for three reasons: He wanted to spoof what he thought as excessive the celebrations in Cedar Rapids and throughout the nation of George Washington's bicentennial in 1932. He wanted to poignard the snooty Daughters of the American Revolution, who clung to aristocratic ways in a democracy. Said he, "They were forever searching through great volumes of history and dusty records, tracing down their Revolutionary ancestry. On the

one hand, they were trying to establish themselves as an aristocracy of birth; on the other, they were trying to support a democracy." And, finally, because he was still miffed that the DAR had criticized his stained-glass war memorial window so much that the dedication plaque had not been installed—and wouldn't be until 1955, long after his death. Too, Leutze was German, and was said to have used various German models for his George Washington, which Grant Wood knew and used as a further dig at the DAR.

The model for the woman holding the willowware teacup, which Wood recalled from his childhood, is his longtime supporter, school principal Frances Prescott. Her hand looks like a chicken's foot, and no doubt Wood wanted it to look that way. The work is redolent with a delicious false officialdom, for he painted the frame with stars along its perimeter and a plaque with the painting's title—perhaps a reference to the missing memorial plaque. The painting is wicked, but not wicked enough to be great—for these caricatures are too insubstantial to possess the milk of human unkindness.

Wood's 1935 *Return From Bohemia* shows the painter in soft focus, half scowling, half pouting, in front of a small crowd of ghostly stereotypes of good ol' downhome midwestern folk. This was followed by some equally insubstantial illustrations for Sinclair Lewis's *Main Street*, and including such downright silly and risible characters as the *Sentimental Yearner*.

Wood's last efforts further tend toward illustration, and have become weak, even laughable formulaic character studies. For example, the curious oil *Parson*

Fig. 13. Wood's only deliberate satire, *Daughters of Revolution*, painted in retribution for the Daughters of the Revolution's criticism of his stained-glass window in the Veterans Memorial Building. (Copyright © Estate of Grant Wood/licensed by VAGA, New York, NY. Printed with permission by Cincinnati Art Museum, The Edwin and Virginia Irwin Memorial.)

Weem's Fable (Fig. 14, page 112). Here, the young George Washington, caught by his father after chopping down the cherry tree and pointing to his little hatchet— "I cannot tell a lie"—has a face as expressionless as the fully mature face painted by Gilbert Stuart. Even though the work is a clever reference to Charles Willson Peale's *The Artist in His Museum*, today in the Philadelphia Academy of Fine Arts, that doesn't save it.

Grant Wood's life ended sadly. In December 1941, nearly destitute—as we have learned, he never had any real regard for money—he was hospitalized with liver cancer, and he died on February 12, 1942, the day before his fifty-first birthday. He was buried in Anamosa.

As a unique honor, the trustees of the Chicago Art Institute had a one-man show of forty-eight of his

works for its fifty-third annual paintings and sculpture show—the only time that such an honor would be given. It was a moving occasion—one, however, that would not be respected by some art critics. The most poignant description of what took place is by one of Grant's friends and clients, Hazel Brown, for whom he had designed and built the shingle-style château in Cedar Rapids.[79]

More than any other painter in the United States he expressed the unabashed simplicity and dignified realism that lay behind the complacent, materialistic exterior of rural midwestern life. Other painters may see, and paint again, the plain, practical beauty of the Iowa landscape. But Grant Wood discovered it. The controversy about Grant Wood, which in his lifetime had run mildly in his home community and his state, was waged bitterly outside these boundaries in the 1930s—the days of his eminence in painting, the days of his most controversial paintings—and raged on at his death and grew more heated at the time of the Memorial Exhibit at the Chicago Art Institute in the fall of 1942 . . . With the invitations that went out announcing the exhibit was a separate engraved card for the special memorial service for Grant Wood. Daniel Cotton Rich, director of fine arts at the Art Institute, wrote to David Turner: "Grant Wood was an art pioneer in his own discovery of America and in his influence on American art. His pictures are selling for as high as $10,000 each. Famous collectors are lending their paintings for this Exhibition . . . it seems to the officials appropriate at this place and at this time. For

Grant Wood was a student of our school, and since American Gothic—which helped to make his reputation—was purchased by us in 1930, is here, we want very much to do him honor"

Many Cedar Rapids people were personally invited to attend the opening of the exhibition. Nan Wood Graham was photographed there, standing in front of Grant's painting of her. Marvin and Winnifred Cone were pictured with Charles Worcester, honorary president of the Art Institute, and Mr. Rich. Marvin's Davis' Dummy was included in the exhibit. David Turner was there, as were John Curry and Park Rinard. Woman With Plant was reproduced for the cover of the program for the exhibit. Inside, Park Rinard, who also had attended the opening of the exhibition, had written: "Through paintings, Grant Wood speaks to the people as few artists have in our time. His was a people's art and so he intended it to be . . . His regionalism was not a narrow aesthetic design or a chauvinistic slogan. It was simply the common sense of the creative mind of the man, the reiteration of an old truth."

The reaction of "common people" to the exhibit was tremendous: appreciation, affection, and defense from those who had read the harsh criticisms in the Chicago papers, particularly from Dorothy Odenheimer, who recalled that Grant Wood was said to be simple, natural, wholesome; however, she said: "This doesn't change the fact that he was a provincial, whose vision was restricted in more than physical sense in the rolling hills of Iowa. He has no taste, no feeling for color, no texture. For a man who lived so close to the soil, his landscapes are remarkable by their coldness, no

atmosphere, no smell of the soil, no wind in the air. These paintings are manufactured to a pattern which soon grows tiresome by repetition. Forty-eight examples oppressed by their coldness. Wood's art is hard and frigid, his approach literal and photographic, you will see how dangerously near his Woman is like his mother! Even in his early Paris days, Wood's diluted attempt at impressionism, or pointillism, was dull, mediocre and undistinguished . . . There are hundreds of artists in Chicago who better deserve a Gallery Show, but Grant Wood occupies "the parlor," successful in death as he was in life, and for the same reasons.

Another Chicago critic, Fritzi Eisenborn, wrote: "Grant Wood's success was due to his being a product of isolationism, his isolationist trend of thought and action rather than his ability as an artist, and contributed nothing. It's a trend of escape thought and action which was popular with some groups yesterday and which is definitely obsolete today. All one sees as he enters the gallery of honor is a yellow, greenish haze. There is hardly a degree of value variation from one end to the other. Grant Wood was without imagination, inventiveness, or inspiration. The covers of *New Yorker* magazine are preferable."

A conservative Chicago art writer, Evelyn Marie Stuart, hit back, saying: "Mrs. Eisenborn's hysterical outburst against Grant Wood, whom she apparently neither understands nor appreciates, comes as a cock-eyed policy in art criticisms. Anyone who reads her stuff should know that ideas in painting are anathema

to her, especially when projected through clear statement in representation. She is the protagonist of the bilious, the bleated, the bleary, the distorted, confused and delirious, masquerading as fanciful, the meaningless and turgid, posing as profound. Grant Wood, although no luscious colorist, is something of an American Hogarth, a satirist of the old original Yankee stock, of the rural districts whose traditions are rooted in our history, and whose appeal to the public is still very strong. It is this, and not museum patronage, which accounts for his Fenerous and tremendous popularity . . . Grant Wood is very 'Ioway' today, and American, always."

C. J. Bulliett, art critic for the *Chicago Daily News*, was one of the first to praise Grant in 1930. The "new" Bulliett, at the time of Grant's death and the memorial exhibit, gave himself credit for starting the vogue for Grant Wood pictures, foreswore his earlier praise, and lamented, sadly, that Wood had an "adroit" talent, a shrewd sense of showmanship, and a sort of political demagoguery that made him seem small-souled. Grant Wood, he said, was one of his "most grievous errors, an error of some twenty years of art criticism. Nothing of the promise of *American Gothic* has been fulfilled. It is still Wood's masterpiece but not worthy of making a painter ranked 'great.' The Memorial Show serves only to point up Wood's weaknesses instead of his small merits . . ."

And Payton Boswell, writing in the *New York Times*, said: "Because the United States is more international-minded today, Grant Wood with all those with him in a long crusade for a genuine native

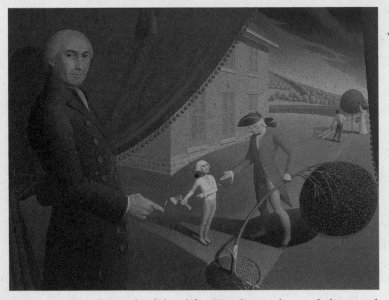

Fig. 14. Near the end of his life, Wood's work trended toward illustration, as shown here in *Parson Weem's Fable*. Grant Wood, *Parson Weem's Fable*, 1939, oil on canvas, 38³/₈ × 50¹/₈ inches, 1970.43, Aman Carter Museum, Forth Worth, TX. (Copyright © Estate of Grant Wood/licensed by VAGA, New York, NY.)

expression in the arts are in the eclipse, today. Flag-waving has become something of a felony. Art is wedded to the social and political events of its time and today is not the time for Grant Wood and his rugged nationalism. Because Grant Wood committed the grievous sin of stressing subject and promoting regionalism, he felt during his last years the full wrath of the international ivory-towerists. To them he was only a 'graphic' artist; to others he was a gifted and sincere painter. It is still too early to make a reliable estimate of his stature among his contemporaries."

Dorothy Doughty, in the Cedar Rapids *Gazette*, spoke for many people of the community when she differed with Fritzi Eisenbom: "Grant Wood an isolationist? He was an anti-appeaser from the start! In 1939, he painted a poster for British War Relief; later he refused to do one for America First. Fritzi Eisenborn says art is international in intent and content as she slays the museums, galleries, and magazines which climbed on the bandwagon of isolationism . . . Happily, Miss Eisenborn, artists do not work in an international vacuum; they interpret the life they know, and their interpretation reflects their nationality. Goya, Vermeer—all through the European scene. Only in that sense does art become international . . . You hang 'isolationism' over *Daughters of Revolution* and this is funny because it is a painting which, in rare Wood humor, pokes fun at that very thing. Unimaginative? Uninventive? Uninspired? You find him insensitive to 'form, shape and color.' Have you seen *Spring in Town* and *Spring in the Country*? Your contemporaries in the critical field have said just the opposite about these paintings. And they, too, were good enough in color to reproduce well. When he was finishing *Spring in the Country* at his studio at Clear Lake, Iowa, he called a Danish farmer over to see it. 'By golly,' said the farmer, 'you can see the shadows under the cowl.'"

Despite the harsh—and, in retrospect, unduly cruel—criticism, *American Gothic* grew and grew, planted itself deeper and deeper into the American psyche, and became a powerful icon, symbolizing the heartland of our country in ways that Grant Wood, even in his most puckish moments, would never have imagined.

Fig. 15. Fellow Iowan Meredith Willson spoofed *American Gothic* in his hugely popular musical *The Music Man* after a decade and a half of obscurity. (Copyright © Estate of Grant Wood/licensed by VAGA, New York, NY. Image supplied by Getty Images, Inc.)

11.

THE ICON

The penultimate item on the connoisseur's checklist is the least important—and the most amusing. It's how other art minds think about the work. In this regard, *American Gothic* is like some wild Rorschach blot enabling viewers to find the most amazing text and subtexts in its austerity and forthrightness, and sometimes even eliciting responses of an antic sort. Like with the Great Sphinx at Giza, people read anything into the image, from the stately and dignified to the perverse and brutal. And like the Sphinx, *American Gothic* has become an icon.

And what does a work of art have to have in order to become an icon? Everything *American Gothic* has:

- A striking, indelible image of mankind that captures people's imaginations from the mo-

ment of its creation.
- High artistic quality.
- Lots of publicity—good and bad.
- Ambiguity.
- A recognizable, or, at least, highly romantic, style.
- Luck.

During World War II, *American Gothic* almost totally faded from the public consciousness. In 1941, *Fortune* magazine suggested that since the "independent, don't-tread-on-me character" of the painting was so "peculiarly American," it would make an ideal anti-German war poster. But the idea wasn't picked up by the War Department.

It was only during the late Eisenhower years that the painting began to slip back into the public eye, at first gradually, and then in a rush—momentum that continues to this day. It is the inspiration for advertisements, political statements, cartoons, and a highly diverse number of caricatures. The painting itself was never parodied, but was used to parody everything in sight. (See the end of the chapter for some recent examples.)

It seems that *American Gothic* first reappeared in *Time* magazine—yet again!—after a decade and a half of obscurity as an illustration accompanying a glowing review of Iowan Meredith Willson's sparky and hugely popular musical, *The Music Man*, which opened on Broadway on December 19, 1957. In the play, two characters, looking like and dressed like Byron McKeeby and Nan Wood, are momentarily framed. (Fig. 15, page 114).

In 1961, Charles Addams, in a cartoon in *The New Yorker*, showed the couple walking out of MoMA galleries—he carrying his pitchfork in an egregious breach of proper art museum etiquette (one has the impression that he might just have spiked one or two of those dangerous, awful European moderns along the way).

Of all the numerous interpretations conjured up by critics, historians, and philosophers of art, it's the historians who are the most measured. But even they at times got sidetracked, mostly because they stopped looking at the painting.

James Johnson Sweeney, a historian who would eventually become the director of the Guggenheim, the Museum of Non-Objective Art, trashed Grant Wood's entire career in a single review published in the *New Republic*.[80] His jargon is memorable. Why was Wood so popular? Sweeney asked. Well, it was only an "economic symptom" of a troubled "popular psychology," the projection of a hard-pressed public's need for reminiscences, associations, anecdotes, and "sentimental symbolism."

Whatever that means.

To Sweeney, Wood was a complete failure because he blew his chances of achieving the "unfamiliar idiom" of a nonassociative but "personalized plastic expression" that must provoke "an intuitive resentment in the observer" in order to succeed as a work of art.

Now we all understand!

Matthew Baigell, an acerbic critic who declared a crusade against anything of a recognizable subject matter or realistic style, in the mid-1970s became the

leading bullhorn against Grant Wood.[81] He Rorschached Byron McKeeby and Nan Wood as "savage" and expressing "a generalized, barely repressed animosity that borders on venom." To Baigell, the painting was first and foremost a satire, mocking "people who would live in a pretentious house with medieval ornamentation, as well as the narrow prejudices associated with life in the Bible Belt."

Baigell focused on the pitchfork, dismissing Wood's idea that it was merely a symbol of old-time farming. It was Devil stuff! "Might we look upon the man with his pitchfork not as a religious farmer—the myth is New Jesus of the midwest—but as the Devil himself, or as a symbol of the Devil's presence in Iowa?"

This somewhat hysterical critic believed that Wood's true identity for years had been masked by overly sympathetic aficionados and friendly critics. "Grant Wood has been so closely associated with corn of one sort or another for so many years that we are prevented from seeing the artist who in a handful of paintings dating from the early 1930s attacked American institutions at least as bitterly as any other American artist."

Balderdash!

Nineteen seventy-four just wasn't Wood's year. Hilton Kramer, then the chief art critic of the *New York Times*, referred to Wood and a "corpse" that he saw "no need to disinter."

Hilton who?

The first serious—and invaluable—study of Grant Wood was published in 1975 by art historian James M. Dennis.[82] He deftly calls *American Gothic* the result of

"personal iconography drawing upon a visual pun, portrait caricature, comic satire, and rural regionalism," and sums up Wood as a "cheerful iconoclast" and a "cosmopolitan satirist."

Then, for some reason, James Dennis became waylaid by that simple Gothic window that had instantly attracted Wood to the modest Eldon house.

> *However, the window holds a second, more profound significance than the eye of the beholder and perhaps even that of the artist may have at first seen. It involves urban appraisal of a rural frame of mind and the resultant negative conception accentuated by the traditional associations of a Gothic arch, so often used in romantic literature to suggest an awesome condition.*
>
> *Although Wood's Gothic window is neatly reconstructed and freshly painted, in contrast to the vacant eyes of Poe's bleak mansions, it does contribute, as a rectangular or round window could not, to the forbidding severity of the faces formally related to it. Also, as the forwardmost factor in a kite-shaped closure secured at its base by a fist, the pitchfork suddenly projects menacingly into clear, magic focus. Unable to escape from its legendary identification as a punitive weapon, over and above its function as a practical tool, it issues a warning to strangers against sudden approach or against any attempt to enter the premises from the edge of the road. It wards off outside threats as determinedly as do the lightning rod and the church steeple, the fourth and fifth prongs pointing toward the sky.*

Devoid of all expression, showing neither compassion nor melancholy, pain nor pleasure, the man and woman are permanently armed against any conclusive speculation as to what they stand for. They will listen to a stranger's query but never answer. The spectator therefore confronts interminably the quiescent couple that haunts the national imagination. Only class, hygiene, and general location can be surmised; otherwise, the two are as closed from further acquaintance as the front of the house behind them. Their mouths are sealed as tightly as the shades of the porch windows, which are drawn to the sills though well protected from the sun by a broad roof. A curtain trimmed with a chain-in-ring pattern behind the divided Gothic frame veils the interior from view, while eyes bore through the observer or avoid contact altogether by gazing to the side, across the direct line of vision.[83]

Dennis's interpretation, I suspect, would have had Wood peering at him fixedly with his rotund headed cocked to the side and bouncing from one foot to the other in frustration.

In 1983, the first major Grant Wood show was mounted since the memorial exhibition in Chicago. It opened at New York's Whitney Museum in June, then went on to Minneapolis and Chicago's Art Institute, closing in the summer of 1984 at the de Young in San Francisco. The grand gathering included eighty-four paintings, drawings, and prints by Wood, as well as three related works by other artists, including a portrait of Wood by John Steuart Curry. The catalogue

is a classic, written by the perceptive twentieth-century-art scholar Wanda Corn.[84]

Corn is, as usual, moderate and sound in her appraisal of *American Gothic*, and her summation of the work stands today as *the* interpretation. "From Wood's perspective, the painting was not about farmers, not about a married couple, and not a satire. It was an affectionate, albeit humorous, portrayal of the kind of insular Victorian relations he had grown up with, whose type still populated, in increasingly dwindling numbers, the villages and small towns of Iowa." And, ". . . he infused the painting with the wit he had long exercised in his personal life—in conversations, costume parties, and gag pieces—but had never allowed into his art. It is, in fact, the gentle humor in *American Gothic* that has caused so much confusion about the picture and led so many to think Wood was ridiculing his subjects." She convincingly points out, "By and large, the farther a critic lived from the Midwest, the more predisposed he or she was to read the painting as satire or social criticism. Local commentators usually saw the painting in a more benign light."

Wanda Corn was only slightly off by insisting that from the start, the couple was always intended by the artist to be farmer and daughter when we know from Wood's own words that he wanted a husband and wife. And she was miles off, I think, about the phallic pitchfork.[85]

Perhaps the most useless interpretation of *American Gothic* (outside of Hilton Kramer's dyspeptic seizure) was written—and broadcast on television—by

the former art critic of *Time* magazine, Robert Hughes.[86] (Yes, *Time* comes back for a third act!) He outs Wood as homosexual—a statement with no background or sources, but which, nonetheless, probably is true—and he calls the work "an exercise in sly camp, the expression of a gay sensibility so cautious that it can hardly bring itself to mock its objects openly."

It's clear that he just never looked at *American Gothic*.

A particularly intriguing take on Grant Wood and *American Gothic* comes from the philosopher John Seery, writing in 2002. He believes that Wood is in no way a "regional" painter but a shrewd, canny, and well-disguised "national political commentator" who is the master of twentieth-century visual irony. "I submit that Grant Wood should be seen in the main as a national political commentator, not simply as a regionalist painter (as is the wont of many art historians), and that something akin to what we would conventionally call 'irony' informs his political paintings."[87]

Maybe so.

Or, perhaps, as I firmly believe, Grant Wood is the only one to listen to about the meaning of his triumphant *American Gothic*—at least at the first flush.

Fig. 16–18. A beloved part of American pop culture, *American Gothic* is often lampooned. (All photos copyright © Corbis. All rights reserved.)

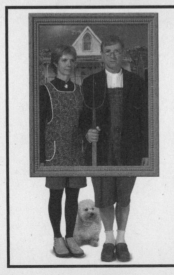

Fig. 19–21. *American Gothic* has been used in advertisement as in the Newman's Own label (*top*) and Dansko clogs promotion (*left*), as well as for social commentary such as *African American Gothic* (*right*).

12.

THE VALUE

In the checklist, curators are asked what the value of the object is and what they might pay for it.

The value of *American Gothic* is nothing. For it is priceless.

13.

BACK TO YOUR
FIRST IMPRESSION

The last thing to do on the checklist is to go back to your initial gut reaction, that flashing first impression, to see if it still stands up after you have peeled *American Gothic* apart like an onion.

Mine does: "Nicely tight. Powerful reality and witty visuals combined. Late Gothic European style."

In technique, composition, meaning, and impression, *American Gothic* is disciplined, tight, terse, and perfectly organized. The work that I found powerful at first glance seems to get stronger the more I look at it. I also keep discovering subtle new visual puns and cross-references, and deft reminiscences of the masters of the late Gothic period. Above all, the fundamental mystery and ambiguity of the work endures.

What else to expect from this marvelous portrait, one of the best painted in America in the entire twentieth century?

APPENDIX:
THE CHECKLIST

This following checklist, at one time used broadly at the Metropolitan Museum of Art, gave rise to the complex acquisitions form that every curator with a purchase or prospective gift would fill out for the examination by the acquisitions committee of the board of trustees.

It looked like this:

RECOMMENDED PURCHASE-CURATOR'S REPORT
Classification
Attach at least one photograph of the object(s)
to the Director and Vice-Director, copies.

I. Name the title, artist, nationality or school, period, material, dimensions in inches and centimeters.

II. Full description of the object. Provide a complete visual account, including the description of all parts. Transcribe any inscriptions, describe marks and mention any added attachments or missing parts, etc.

III. Describe the condition of the piece, indicating any repairs and attempting a prognosis for future condition (how fragile is the piece?). Name the results obtained from scientific investigations, whether of microscopy, chemical tests, X-ray, infra-red, ultra-violet, spectrographic analysis, thermoluminescence, etc.

IV. State the function of the piece, and whether anything about the object indicates its function as part of a greater whole or as an independent work.

V. State the iconography of the object. Does it follow traditional iconography, or is there something unusual in its iconography?

VI. Stylistic considerations
 A. State briefly your initial reaction to the object.
 B. Describe the style and relate the style of the piece to the appropriate artist, school, period, etc.
 C. Discuss and illustrate the two or three pieces that make the best stylistic comparisons with this piece. Indicate what distinctive qualities this piece has in relation to them in terms of style, technique, condition, documentation, etc.
 D. Provide a list of all relevant works of art, whether copies, variants or other closely similar compositions, pointing out the relationship to each work named.

VII. State how the work of art complements the existing Museum collections or how a gap.

VIII. Explain your plans for exhibiting and publishing the piece.

IX. Give the history of the piece, all known provenance with traditional documentation, when available. Include any hearsay evidence or traditional provenance, with source.

X. Give any significant archaeological information.

XI. List all published references, pointing out those of greatest importance. Also include any expert advice sought or volunteered from outside the Museum.

XII. Give a résumé of your reasons for deciding to recommend the piece, being candid as to its strengths and weaknesses, its rarity of quality, technique, type, etc. Mention any problem outstanding that could affect the decision to buy.

XIII. Tell how long you have known of the piece and give a history of the negotiations.

XIV. If possible, give recent market prices for comparable works of art.

XV. Financial considerations
A. If the object is to be purchased, state the price.
B. Fund?
C. Exchange? What might be traded off for it?
D. Additional expenses.
E. State chances for bargaining.

ENDNOTES

1. I personally learned the importance of gut reaction to art as a Princeton University undergraduate majoring in art and archaeology and sitting in on a graduate seminar on modern sculpture. The professor placed a small, abstract silver sculpture mounted on a polished wooden stand on a table in front of the class and asked for our comments. It vaguely resembled the work of British sculptor Henry Moore. I spoke last, since I was not officially enrolled in the seminar. I had listened to a number of learned and sometimes flowery assessments: "classicizing softness of the rounded forms," "the capable zeitgeist of the entropy of hidden antique forms," "iconographically, it leans toward the Henry Moore school, with a debt to Matisse." Feeling like I was in kindergarten, I gulped, then said, "I don't feel it's a work of art at all." The other students smirked, but the professor snapped, "Only the undergraduate got it right; it's a vaginal spatula."

2. I recall with amusement the seminar on Jan van Eyck where the great Irwin Panofsky, perhaps the world's most accomplished art historian ever, muttered to me that he was beginning to believe that the early fifteenth-century Flemish painter must have known Sanskrit, because an image in one of his paintings appeared to mirror an obscure philosophical text. Panofsky is also supposed to have blurted out, "Damn the originals, I prefer

131

black-and-white photos." That's a fact; he said it to me once when he inadvertently dropped a burning cigarette into a priceless Leonardo elephant folio volume and closed it. But for his field, he was right; he was into iconology, and iconology is all about subject matter and its interpretation.

3. I remember getting into a fracas with a historian who insisted that the great French seventeenth-century Tenebrist Georges de La Tour had traveled to Rome at a critical part in his career. I pointed out that during those very same years, La Tour's wife had produced eighteen children.

4. "Gothic" was dreamed up by a late Renaissance Italian artist and art historian to denigrate that ugly style up north where the provincials hung out. "Cubism" was a put-down, as was "impressionism," although, to be accurate, these names were thrown out by art critics, not art historians, who nonetheless persist in using them.

5. AIC vouches for its condition.

6. I've done it many times with medieval works that had just emerged after centuries of being hidden away someplace. Often the hunt for a comparable style is arduous. I remember once spending three months of searching through photographs and illustrations in all sorts of publications for anything that had the vaguest stylistic resemblance to a twelfth-century ivory that had just turned up out of nowhere.

When I found a work that had even the slightest resemblance, I set it aside. After sifting through virtually every published work on the twelfth century, I had a stack of about fifty photographs depicting a faintly similar style. I then winnowed these down to about a dozen that were significantly close—especially in drapery style, which, for medieval works, is paramount to the signature style.

When I learned that every one of my dozen choices, ranging from manuscript illuminations to seal impressions to sculptures, had something to do with a certain renowned mid-twelfth-century English monastery, I knew where to go to look further. Eventually, I was able to pin the work down to a specific location, a specific artist, and a specific date.

7. James M. Dennis, *Grant Wood: A Study in American Art and Culture* (New York: Viking, 1975). For sources, see: the Davenport Museum of Art has collected eighteen volumes of

published articles on Wood's work, plus copious correspondence collected by his sister. The Archives of American Art at the Smithsonian Institute contains a wealth of materials relating to the artist's life and oeuvre. The three most valuable studies of Wood are: Dennis, *Grant Wood*; Wanda M. Corn, *Grant Wood: The Regionalist Vision* (New Haven: Yale University Press, 1983); and Darrell Garwood, *Artist in Iowa* (Westport, Conn.: Greenwood Press, 1944).

8. Garwood, *Artist in Iowa*, p. 120. Garwood's unauthorized biography was based not only on many conversations with the artist but on interviews with his friends. The writing is homespun and anecdotal. Inaccuracies involve only relatively insignificant details. I found that for the most part, what Garwood said checked out pretty well. Wood's sister, Nan Wood Graham, who published her own version of her brother's life, seems to have resented Garwood's efforts. Apparently, he wasn't as hagiographical as she wanted.

9. Ibid., p. 122.

10. The house still exists. It was placed on the National Register of Historic Places in 1974, and in 1991 was presented to the State Historical Society by Carl E. Smith. In 1992, it was restored to its 1930 condition. While you can't enter the house because a caretaker lives there, visitors are encouraged to pose for photographs in front of it.

The Web site of the Historical Society of Iowa states:

American Gothic House
Eldon, Iowa

Strike an *American Gothic* pose and take a photograph in front of the small white house made famous by Iowan Grant Wood, one of America's most beloved artists.

Although not open to the public, visitors are welcome to view the house from the outside, as Grant Wood did in 1930 when he was inspired by its unusual Gothic window. The State Historical Society of Iowa owns and preserves the American Gothic House. It is listed on the National Register of Historic Places.

You can celebrate Gothic Day in Eldon the second Saturday in June every year. Visit the various gift shops in Eldon. Eat home-cooked meals at Jones Cafe on Main Street.

Eldon is located in the Des Moines River Valley, where

outdoor enthusiasts can find hiking, fishing and hunting opportunities. For more information contact:

Shaner Magalhaes
State Historical Society of Iowa
402 Iowa Avenue
Iowa City , IA 52240-1806
Telephone: 319-335-3916
E-mail: Shaner.Magalhaes@iowa.gov

There's a delightful article written by Jerry Schwartz for the *Los Angeles Times* August 5, 2001.

The Nation
The Background Story of American Gothic Arts

The Iowa house in Grant Wood's painting still draws those who seek to connect with a cultural icon. What makes this painting a symbol, and how did it come to be?

Bruce Thiher is accustomed to opening his door and finding pilgrims who have driven long miles to this no-stoplight railroad town where the trains don't go anymore.

They have not come to see Thiher. They are there to see his little house.

It is one of the most famous shelters in America, though it has never housed anyone famous. But it is instantly recognizable—the porch, the pointed roof, the churchlike window on the second floor.

You've probably seen it hundreds of times, always in the background, behind a dour man with a three-pronged pitchfork and a woman whose face, a writer once said, would "sour milk."

Sometimes, in the hands of parodists, the man and woman have metamorphosed into Ronald and Nancy Reagan, Bill and Hillary Clinton, even Kermit the Frog and Miss Piggy. Or gas masks have been placed on their faces, or they've been dressed in Ku Klux Klan robes or kinky leather.

But it was the house that inspired a little-known artist named Grant Wood to create his masterpiece, *American Gothic*.

"There's something magical about it, I guess," says Lowey Cordova.

Cordova had made the seventy-mile trip from Knoxville, Iowa, to Eldon with Beverly Smith. Smith suggested this pilgrimage; she had recently re-created *American Gothic* in needlepoint.

To their surprise, Thiher opens the door and invites them in. He is Eldon's postmaster, and has rented the *American Gothic* house from the state since 1996. The previous tenant, an elderly woman, did not much like visitors, but Thiher welcomes them: "You meet a lot of interesting people."

He tells them about the house's history, about Grant Wood. They listen closely, even if it is not clear exactly why they have come all this way to see this old frame house that is not, truth be told, all that different from other old houses. Just as it is not clear why *American Gothic*—like the *Mona Lisa*, like *Whistler's Mother*—holds a place among that small number of paintings that have become more than paintings.

"It's an icon of Iowa," says Thiher, a large, gregarious man of fifty-four who put down his cereal bowl to show the house. "There is the element of humor, and yet he has effectively portrayed the virtues of plainness, simplicity and hard work which still epitomize the way Iowa people think of themselves today."

And, indeed, Cedar Rapids, Wood's hometown, has populated its streets this summer with fiberglass versions of the *American Gothic* characters—among them, *American Gothic* beatniks, Uncle Sam and Lady Liberty, baseball and hockey players, and mimes.

But *American Gothic* is not just Iowa.

Otherwise, why would an Italian magazine editor and cartoonist take the Gothic pose for a recent ad? And why would the film *Men in Black* feature a cover of a supermarket tabloid, depicting an alien in bib overalls alongside the Gothic woman under the headline "Alien Stole My Husband's Skin"?

"It's very difficult to propose a reason why something transcends everything in its class," says Daniel Schulman, associate curator of modern and contemporary art at the Art Institute of Chicago, where *American Gothic* hangs. "Nobody has the answer."

He concedes that Wood's masterpiece has become so familiar that "it makes it hard to look at the painting with fresh eyes." But there was a time when *American Gothic* was a sensation.

"In those sad and yet fanatical faces may be read much of what is Right and what is Wrong with America . . . ," wrote editor Christopher Morley in 1971. "It seemed to be one of the most thrilling American paintings I had ever seen."

He saw *American Gothic* at its debut, the annual exhibition of American paintings and sculpture at the Art Institute in 1930. Grant Wood's painting almost didn't make it; most of the jury

didn't especially like it, and it was only through the lobbying of juror Percy Eckhart—the museum's lawyer—that *American Gothic* was accepted for the exhibit.

But when you look at the catalogue for the show, says Wanda Corn, professor of art history at Stanford University and author of *Grant Wood: The Regionalist Vision*, you'll find "a rather humdrum group of Impressionist, Expressionist and Cubist paintings," nothing that compares with Wood's "very sharply focused, detailed, tough image."

The Friends of American Art at the Art Institute paid $300 for *American Gothic*—a nice investment, as it turned out.

Grant Wood also took home a bronze medal, a $300 prize, and sudden fame.

Before *American Gothic*, he was a successful artist, but mostly in Cedar Rapids, where he had painted portraits and murals on commission, decorated homes, taught school, and created a large stained-glass window for the town's Veterans Memorial Building.

He was a hometown boy, with local patrons and a reputation as a gregarious (if sometimes distracted) neighbor who generally wore bib overalls. He spent a year or two in Europe, and came back with a Bohemian beard. He got rid of it before too long. It just wasn't Iowa.

He was not so quick to discard other European leanings. Many of his paintings from the 1920s are impressionistic French scenes. Gradually, he began to look closer to home for his subjects; his most useful, authentic reference book, he said, was the Sears Roebuck catalogue.

"The really good ideas I'd ever had came to me while I was milking a cow," he once said. "So I went back to Iowa."

In August 1930, he went to Eldon to give a painting demonstration. On a hot summer day—Thiher says the southerly breeze from the stockyards across the way brought a real Iowa fragrance to the moment—Wood caught sight of the house and its "pretentious" Gothic window.

Right away, he envisioned a painting with a man and woman in the foreground, their features elongated to match the house's vertical lines. He scribbled a sketch on an envelope, and when he went back to Cedar Rapids he asked for a photograph of the house.

American Gothic took about two and a half months to complete. The man, the woman, and the house were painted separately. For the man, he chose his dentist, Dr. Byron H. McKeeby. For the woman, he chose his sister, Nan Wood Graham.

From the beginning, *American Gothic* provoked arguments. Who were these people?

Wanda Corn says Wood intended them to be father and daughter, but others saw them as husband and wife. (Last year, *American Heritage* used a riven *American Gothic* for a cover on divorce.)

Then there were those who complained that Wood was making fun of small-towners—an accusation that Wood denied heatedly. This was not satire, he insisted. "I admit to the fanaticism and false taste of the characters in *American Gothic*, but to me, they are basically good and solid people," he wrote.

The controversy did nothing to hurt Wood's star status among the American regionalists—artists like Thomas Hart Benton and John Steuart Curry, who found their inspiration in their own backyard and their subjects in the common folk.

To some in the art world, Wood's work was too simple, too obvious. But with the rise of Nazism, the word "folk" took on a different meaning. Wood's paintings began to look like the Aryan art the Germans so loved, Corn says. By the time he died of liver cancer in 1942, a day before his fifty-first birthday, his career was in decline.

There was a memorial exhibition in Chicago, but the New York–centered art world ignored it. "People just stopped talking about him," Corn says

Grant Wood—and his most famous painting—went into eclipse. But only for a few years.

In 1962, H. W. Janson first published his *History of Art*, a monumental survey that covered everything, from Greek sculpture to, well, *American Gothic*. Janson and others contributed to a democratization of art, Corn says; the art world's experts lost control of an expanded canon that was within reach of everybody—to appreciate, to parody, to customize.

"When Joe Shmoe opens his newspaper and sees the *Mona Lisa* with a mustache, it means something to Joe Shmoe that it wouldn't have meant fifty years before," Corn says.

So *American Gothic* is reproduced in myriad ways. And as a result, the New York–based Visual Artists and Galleries Association. is a busy watchdog—serving as agent for those who own the rights to *American Gothic*, the Art Institute and the ten beneficiaries of Nan Wood Graham, who died in 1990.

"People think, 'I've seen it so much, I can do whatever I want with it,'" says Robert Panzer, VAGA's executive director. But no one has the right to reproduce *American Gothic* without permission. "It is not the public's," he insists.

He relies on two arguments:

- Copyright. The copyright on *American Gothic* does not expire until 2025—if, in fact, it is valid (given the laxness of Wood and his estate in affixing and renewing the copyright).
- The right of publicity. Nan Wood Graham spent most of her life in California, which has strong laws giving celebrities the rights to their likenesses. She was her brother's fiercest champion. She threatened to sue Johnny Carson and *Penthouse* magazine, among others, for using *American Gothic* in what she deemed poor taste.

Panzer will not say how much money the painting earns from commercial usages ("Let me put it this way: It's not making anybody rich"). But one beneficiary, David Rozen, of Millbrae, California, says he and his wife, Martha, receive less than $5,000 a year. That could put the total for all the heirs, the Art Institute and VAGA at less than $150,000.

Panzer makes no friends with his vigilance. When he demanded that Larry Jordan, publisher of *Midwest Today*, remove *American Gothic* from his magazine's Web site, Jordan fired back, calling Panzer's action "elitist and paranoid."

Panzer also tussled with the organizers of Cedar Rapids' celebration of Grant Wood, "Overalls All Over: An American Gothic Happening."

By the time a settlement was reached—no cash changed hands--the exhibit had opened. And on a First Avenue sidewalk, fifty-four-year-old Linda Rae Norton had come face-to-face with an *American Gothic* pair dressed as rockers, with tinsel for hair and a microphone in place of a pitchfork.

A third-grade teacher at Grant Wood Elementary School, Norton was almost overcome with excitement at the opening back in June. "I hardly slept last night," she said. She is a self-professed Wood fanatic; among other things, she has created Grant Wood playing cards for her students.

"He is up there in heaven, up there just enjoying this," she said. "He loved parties."

That same weekend, the town in which Wood was born and buried, Anamosa, sponsored the twenty-ninth annual Grant Wood Art Festival. Thousands turned out; none took the organizers up on their offer of free admission to anyone dressed as the *Gothic* duo.

On Anamosa's Main Street, there is a Grant Wood Tourism Center and Gallery, full of published riffs on *American Gothic*.

Exploiting Anamosa's connection to Wood is a way of bringing visitors to the town of five thousand people, just as the organizers of "Overalls All Over" hoped it would promote Cedar Rapids tourism.

But Cecilia Hatcher and her husband, John, cochairs of the art festival, say there is more to it than that. In Grant Wood, they say, they are celebrating something inherently American.

"Look at *American Gothic*," Cecilia says. "It's just solid American values is what he is painting, and that's what people see in it."

Not long ago, she says, she saw an *American Gothic* in which one character was black and the other Hispanic. "That's the new America."

But does *American Gothic* really reflect America 2001?

Wanda Corn makes the case that Wood didn't even intend his work to reflect America 1930. Instead, she says, Wood was inspired by the people he knew in Anamosa, the small town he left in 1901 when he was ten years old, after his father died.

Of course, there are still farmers and small-town people, in Iowa and elsewhere. Some of them even bear more than a passing resemblance to the *American Gothic* couple. "If you'd like, I could introduce you to my aunt and uncle, who pretty much look like that today," says Jordan, *Midwest Today* publisher.

Still, he asks, "How many kids really know what a pitchfork is and what it's used for?"

Daniel Schulman has seen a change at the Art Institute. *American Gothic* hangs in the same intimate gallery with Edward Hopper's *Nighthawks*, a dark and moody depiction of an all-night cafe. Over the last ten or fifteen years, *Nighthawks* has become a greater draw for visitors, Schulman says, and has been referred to more often on TV, in movies, and in other artwork.

The reason, to Schulman's mind: "The nighthawks are urban dwellers."

And more and more, so are we.

There's no chance that *American Gothic* will recede into obscurity any time soon. Friends around the world still send Wanda Corn new parodies every week. Children still flock to the gallery, point to the funny-looking couple on the wall, and say, "See that?"

And Bruce Thiher still welcomes visitors to the old house in Eldon—people like Jeremy Schultz, twenty-four, and Lori Cortelyou, twenty-six, of nearby Ottumwa. They looked around, chatted with Thiher, checked out the table of souvenirs (including bolo ties with wooden clips in the shape of the

house's famous windows).

　　It was a worthwhile visit, they agreed afterward.

　　"It's unique," Schultz said. "How many *American Gothic*s are there?"

　　Really, only one.

11. A quote found by Brady M. Roberts, given to John E. Seery, and published in his *America Goes to College: Political Theory for the Liberal Arts* (Albany: State University of New York Press, 2002), p. 125.

12. Corn, *Grant Wood*, p. 129, fig. 153.

13. Currently in the possession of Red Grooms and reference to Corn, fig. 157, on p. 131.

14. Grant Wood, letter to the editor, printed in "The Sunday *Register*'s Open Forum," *Des Moines Register*, December 21, 1930. See also Archives of American Art, 1216/286.

15. Seery, *America Goes to College*, p. 225, footnote 37. See also *Archives of American Art*, 1216/286.

16. Wood, letter to the editor, *Des Moines Register*.

17. Corn, p. 159.

18. Seery, quoting Brady M. Roberts, p. 125.

19. From www.metropulse.com "In Praise of Overalls and Famous Men," by Jay Hardwig. "McKeeby's son, also named Byron McKeeby, was a printmaker and member of the University of Tennessee art faculty. His grandsons, Paulo and Neal, grew up in Knoxville, attending West and Bearden High; Paulo is now a Dallas attorney, while Neal plays guitar with Drums & Tuba."

20. Garwood, *Artist in Iowa*, p. 129.

21. Ibid, p. 120.

22. Ibid, p. 122.

23. Ibid, p. 124.

24. Ibid.

25. Ibid.

26. Ibid, p. 122.

27. Published in Corn, *Grant Wood*, fig. 158.

28. "Grant Wood Denies Reputation As Glamour Boy of Painters," *Los Angeles Times*, February 19, 1940. See also Archives of American Art, 1216.

29. Corn, *Grant Wood*, p. 130, fig. 154. Wanda Corn also observes perspicaciously that when Wood was seventeen he made a yearbook illustration that copied a tintype of his mother, Hattie Weaver Wood, as a child, stiffly frontal, elaborate frame and all (p. 88, and in figs. 119 and 120). Corn also speculates (p. 130) that "In placing the man and woman squarely in front of their house, he borrowed another photographic convention, this one from those post–Civil War itinerant photographers who traveled rural America making portraits of couples and families in front of their homes . . . Wood might well have known the classic photographs of this type made by Solomon D. Butcher (1856–1927) and published in two books in 1901 and 1904. A photographer and amateur historian, Butcher documented Nebraskans from the pioneer days of sod houses through to the next generation of prim wooden houses and cultivated lawns. But even if Butcher's photographs were unfamiliar to Wood, similar images were common stock in most midwestern family albums, and by the turn of the century these portraits were even made into postcards for families to send to distant relatives and friends. In such photographs men and women often posed with emblems or attributes appropriate to their status and occupation, a convention borrowed from a much older tradition of portrait painting. Men held shovels, rakes, or pitchforks; women leaned on brooms or chairs or tended plants. Potted plants especially, whether in a window, on a porch, on a lap, or on a crude table in front of a sod house, symbolized a woman's nurturing and horticultural skills. In the Midwest, where winters are long and bitter, keeping plants alive was a recognized female achievement."

Wood might have gone to that trouble in his research, but, still, I think what Corn gingerly puts on the table seems like an overly art-historical longshot (dare I say, it's on the edge of being *"horsegeschichterly"*) in light of the clear and obvious facts that Wood had been fascinated by his doctor's face and physique,

had come across a Gothic house by chance, and decided with an artist's typical impetuosity to bring the two together. Artists, unlike art historians and art critics, are almost obsessively visual, and make sudden—and, to us mortals, incomprehensible—visual connections all the time.

30. This according to Corn, *Grant Wood*, p. 129, with no attribution, although she may have found a reference to it in the Davenport archives. I wonder—the story sounds too serendipitous and cutesy.

31. Quoted in an article entitled "An Iowa Secret," *Art Digest* 8 (October 1933). The quote about the pitchfork shows me up! For, in my detailed written description of the painting, I had mused that the pitchfork looked unreal, and may have been painted from a photograph or from Wood's imagination. Actually, I still think the doctor never held a real pitchfork for however many hours it took to get him down on the composition board. The pitchfork in the painting wouldn't hoist fifty pounds of hay. Just goes to show, you can't trust the word of an artist.

32. Irma R. Koen, "The Art of Grant Wood," *Christian Science Monitor*, March 26, 1932.

33. Letter to the editor from Grant Wood, printed in "The Sunday *Register*'s Open Forum," *Des Moines Register*, December 21, 1930. See also Archives of American Art, 1216/286.

34. Garwood, *Artist in Iowa*, p. 120. I personally don't think that assigning a particular name to a given subject matter necessarily means it will emerge as satire or caricature.

35. Garwood, p. 124, claims that Wood deliberately avoided the fair because he was concerned that the farmer audience would be offended by the pointed satire in *American Gothic*. This wasn't so, because the fair, then as now, is held in mid-August, and the painting wasn't yet finished. Garwood is off base in thinking that the picture is such an intense satire, and that Wood was deeply worried about its reception. He also mixes up dates, putting Wood's later spins on the meaning of the painting earlier than Wood actually voiced them. Garwood writes, "*American Gothic*, the actual painting of which Grant spent three months, could have been ready for the Iowa State Fair of 1930 but wasn't shown there for obvious reasons. The fair with its

livestock, crop and gardening exhibits and incidental amusement-park features, is primarily for farmers. No one knew what kind of a protest they would raise over being portrayed in this vein. Grant anticipated trouble, and to mollify the farmers insisted almost from the first that the man in *American Gothic* was a bald-headed spectacled small-town businessman." James Seery, in *America Goes to College*, also picks up on Garwood and assumes Wood didn't dare show the work at the state fair.

36. Corn, *Grant Wood*, p. 72.

37. "What he had already achieved seemed worthless. He felt a new kind of freedom. He took advantage of the fact that he had nothing to lose—first to do the kind of work he liked and, second, to strike out for greater recognition. Instead of mellow, wistful effects, he now looked for striking qualities and was ready to use strong emphasis and satire." Garwood, *Artist in Iowa*, p. 126.

38. When I first saw *Stone City*, I was reminded of the works of the New York surrealist Peter Blume, such as *The Eternal City* of 1934 in MoMA and early works by the Belgian surrealist René Magritte, such as *The Lost Jockey*. Yet, looking into whether or not Wood could have seen pieces by Magritte or Blume, I conclude that it's impossible. Magritte had his first show in Brussels a year after Wood had left Belgium. Blume showed in New York in the early 1930s, but it's highly doubtful Wood ever came across his works.

39. Information sent to me by the Chicago Art Institute archivist Bart Ryckbosch.

40. Article in the archives of the Art Institute, kindly sent to me by Bart Ryckbosch.

41. Bulliett quoted at length in *Art Digest* 5, no. 3 (1930), pp. 4–7.

42. Ibid.

43. In Wood scrapbooks, Archives of American Art, 1216/282. See also *Boston Herald*, November 14, 1930, and Corn, *Grant Wood*.

44. Changing his earlier statements that he was seeking a farmer and his wife. Clearly, Wood could not take criticism of any sort.

45. In "The Sunday *Register*'s Open Forum," *Des Moines Register*, November 30, 1930.

46. Corn, p. 130.

47. Seery, *America Goes to College*, p. 125. Ironically, the one Sigmund poem that seems to relate to this painting is "The Serpent," which refers to a spinster daughter as a sexless monster. For Sigmund, the spinster was a "smug and well-kept" woman with a "saintly smile" that betrayed her hypocrisy, an "arch-assassin of reputation" whose fangs were no "less cruel and deadly for being hidden."

48. "Open Forum," *Des Moines Register*, December 21, 1930.

49. Corn, p. 132.

50. Garwood, *Artist in Iowa*, pp. 13–15, 17.

51. Ibid., p. 18.

52. Ibid., p. 19.

53. Ibid., p. 30.

54. Ibid., p. 27.

55. Corn, p. 112.

56. Dennis, *Grant Wood*, chapter 4.

57. Ibid.

58. Corn, pp. 8–9.

59. *Grant Wood at 5 Turner Alley*
Housing the world's largest collection of works by American Regionalist artist Grant Wood, the Cedar Rapids Museum of Art owns and operates Wood's nearby studio known as 5 Turner Alley. For the period September 10 through December 4, 2005 the Museum has organized a major exhibition illustration the integrated nature of the paintings, murals and functional decorative works Wood created during 1924 to 1934, the creative and prolific decade in which he lived at 5 Turner Alley. It was in this studio, which Wood designed

and hand-built, that he painted *American Gothic*, which will make a rare trip from the Art Institute of Chicago to join other important loans and works from the CRMA's collection for this exhibition.

Cedar Rapids Museum of Art
410 Third Avenue SE
Cedar Rapids, Iowa 52401
319.366.7503
319.366.4111 (fax)
www.crma.org
www.granwoodstudio.org
info@crma.org

60. Corn, pp. 5 and 21–22.

62. Ibid., p. 26.

63. Garwood, pp. 33–34, has this to say about the glass: "Out of his new attraction to the Flemish primitives, his increased preoccupation with small details, and a new boldness which appeared in his work after the chill reception of his memorial window—out of a combination of all these things grew *American Gothic*. The novelty of being an artist and of conforming to standard practices in order to be accepted had worn off. What he had already achieved seemed worthless. He felt a new kind of freedom. He took advantage of the fact that he had nothing to lose—first, to do the kind of work he liked, and, second, to strike out for greater recognition. Instead of mellow, wistful effects, be now looked for striking qualities and was ready to use strong emphasis and satire."

64. Koen, "The Art of Grant Wood."

65. Ibid.

66. Brady Roberts, "The European Roots of Regionalism: Grant Wood's Stylistic Synthesis," in *Grant Wood Revisited* (Davenport, Iowa: Davenport Museum of Art, 1995), pp. 24–27. Roberts is convinced of "the New Objectivity" link. It seems very slim to me.

67. Corn, p. 33.

68. Seery, p. 121.

69. Corn, p. 33.

70. Ibid.

71. Ibid., p. 42.

72. Ibid.

73. Internet,
 www.xroads.virginia.edu/~MA98/haven/wood/intro.html

74. Corn, pp. 32 and 41. See also *New York Herald-Tribune*, January 19, 1936, and Archives of American Art, 1216.

75. Samuel Kootz, *New Frontiers in American Painting* (New York: Hastings House, 1943), pp. 10–14.

76. See "Benton and Wood, Champions of Regionalism," *Magazine of Art* 4, no. 39 (May 1946), pp. 184–86, 198–200.

77. Robert Hughes, *American Visions: The Epic History of Art in America* (New York: Knopf, 1997), p. 194.

78. Full text of "Revolt Against the City" by Grant Wood:
 The present revolt against the domination exercised over art and letters and over much of our thinking and living by Eastern capitals of finance and politics brings up many considerations that ought to be widely discussed. It is no isolated phenomenon, and it is not to be understood without consideration of its historical, social, and artistic backgrounds. And though I am not setting out, in this essay, to trace and elaborate all of these backgrounds and implications, I wish to suggest a few of them in the following pages.
 One reason for speaking out at this time lies in the fact that the movement I am discussing has come upon us rather gradually and without much blowing of trumpets, so that many observers are scarcely aware of its existence. It deserves, and I hope it may soon have, a much more thorough consideration than I give it here.
 But if it is not vocal—at least in the sense of issuing pronunciamentos, challenges, and new credos—the revolt is certainly very active. In literature, though by no means new, the exploitation of the sixty-four provinces has increased remarkably; the South, the Middle West, the Southwest have at the moment hosts of interpreters whose Pulitzer Prize works and

best-sellers direct attention to their chosen regions. In drama, men like Paul Green, Lynn Riggs, and Jack Kirkland have been succeeding in something that a few years ago seemed impossible—actually interesting Broadway in something besides Broadway. In painting there has been a definite swing to a like regionalism; and this has been aided by such factors as the rejection of French domination, a growing consciousness of the art materials in the distinctively rural districts of America, and the system of PWA artwork. These developments have correlations in the economic swing toward the country, in the back-to-the-land movement—that social phenomenon which Mr. Ralph Borsodi calls the "flight" from the city.

In short, America has turned introspective. Whether or not one adopts the philosophy of the "America Self-Contained" group, it is certain that the Depression era has stimulated us to a reevaluation of our resources in both art and economics, and that this turning of our eyes inward upon ourselves has awakened us to values which were little known before the grand crash of 1929 and which are chiefly nonurban.

Mr. Carl Van Doren has pointed out the interesting fact that America rediscovers herself every thirty years or so. About once in each generation, directed by political or economic or artistic impulses, we have reevaluated or reinterpreted ourselves. It happened in 1776, of course, and again a generation later with the Louisiana Purchase and subsequent explorations and the begin-nings of a national literature. It came again with the expansion of the Jacksonian era in the eighteen thirties, accompanied by a literary flowering not only in New England but in various frontier regions. It was marked in the period immediately after our Civil War, when Emerson observed that a new map of America had been unrolled before us. In the expansionist period at the turn of the century, shortly after the Spanish War, when the United States found herself a full-fledged world power, we had a new discovery of resources and values. And now, with another thirty-year cycle, it comes again. It is always slightly different, always complex in its causes and phenomena; but happily, it is always enlightening.

Moreover, these periods of national awakening to our own resources have always been in some degree reactions from foreign relationships. These reactions are obvious even to the casual reader of history and need not be listed here except as to their bearing on the present rediscovery. Economic and political causes have contributed in these days to turn us away from Europe—high tariff walls, repudiation of debts by European nations, the reaction against sixty-four entangling alliances,

which followed upon President Wilson's effort to bring this country into the League of Nations, and the depression propaganda for "America Self-Contained."

But one does not need to be an isolationist to recognize the good which our artistic and literary secession from Europe has done us. For example, until fifteen years ago it was practically impossible for a painter to be recognized as an artist in America without having behind him the prestige of training either in Paris or Munich, while today the American artist looks upon a trip to Europe as any tourist looks upon it—not as a means of technical training or a method of winning an art reputation but as a valid way to get perspective by foreign travel. This is a victory for American art of incalculable value. The long domination of our own art by Europe, and especially by the French, was a deliberately cultivated commercial activity—a business—and dealers connected with the larger New York galleries played into the hands of the French promoters because they themselves found such a connection profitable.

Music, too, labored under similar difficulties. Singers had to study in Germany or Italy or France; they had to sing in a foreign language, and they even had to adopt German or Italian or French names if they were to succeed in opera. In literature the language relationship made us subject especially to England. The whole of the nineteenth century was one long struggle to throw off that domination—a struggle more or less successful, but complicated in these later years by a continuation of the endless line of lionizing lecture tours of English authors and by the attempt to control our culture by the Rhodes scholarships which have been so widely granted.

This European influence has been felt most strongly in the eastern states, and particularly in the great eastern seaport cities. René d'Harnoncourt, the Austrian artist who took charge of the Mexican art exhibit a few years ago and circulated it throughout the United States, and who probably has a clearer understanding of American art conditions than we do who are closer to them, believes that culturally our eastern states are still colonies of Europe. The American artist of today, thinks d'Harnoncourt, must strive not so much against the French influence, which, after all, is merely incidental, but against the whole colonial influence which is so deep-seated in the New England states. The East is nearer to Europe in more than geographical position, and certain it is that the eyes of the seaport cities have long been focused upon the "mother" countries across the sea. But the colonial spirit is, of course,

basically an imitative spirit, and we can have no hope of developing a culture of our own until that subserviency is put in its proper historical place.

Inevitable though it probably was, it seems nevertheless unfortunate that such art appreciation as developed in America in the nineteenth century had to be concentrated in the large cities. For the colonial spirit thereby was given full rein and control. The dominant factor in American social history during the latter part of that century is generally recognized as being the growth of large cities. A. R. Fox, writing an introduction to Arthur M. Schlesinger's *The Growth of the City*, observes: "The United States in the eighties and nineties was trembling between two worlds, one rural and agricultural, the other urban and industrial. In this span of years . . . traditional America gave way to a new America, one more akin to Europe than to its former self, yet retaining an authentic New World quality . . . The present volume is devoted to describing and appraising the new social force which waxed and throve while driving the pioneer culture before it: the city."

This urban growth, whose tremendous power was so effective upon the whole of American society, served, so far as art was concerned, to tighten the grip of traditional imitativeness, for the cities were far less typically American than the frontier areas whose power they usurped. Not only were they the seats of the colonial spirit, but they were inimical to whatever was new, original, and alive in the truly American spirit.

Our Middle West, and indeed the "provinces" in general, have long had much the same attitude toward the East that the coastal 230 cities had toward Europe. Henry James's journey to Paris as a sentimental pilgrim was matched by Hamlin Garland's equally passionate pilgrimage to Boston. It was a phase of the magnetic drawing power of the eastern cities that the whole country, almost up to the present time, looked wistfully eastward for culture; and these seaport centers drew unto them most of the writers, musicians, and artists who could not go on to Europe. And the flight of the "intelligentsia" to Paris was a striking feature of the years immediately after the world war.

The feeling that the East, and perhaps Europe, was the true goal of the seeker after culture was greatly augmented by the literary movement which Mr. Van Doren once dubbed "the revolt against the village." Such books as *Spoon River Anthology* and Main Street brought contempt upon the hinterland—and strength-ened the cityward tendency. H. L. Mencken's urban and European philosophy was exerted in the same direction.

But sweeping changes have come over American culture in the last few years. The Great Depression has taught us many things, and not the least of them is self-reliance. It has thrown down the Tower of Babel erected in the years of a false prosperity; it has sent men and women back to the land; it has caused us to rediscover some of the old frontier virtues. In cutting us off from traditional but more artificial values, it has thrown us back upon certain true and fundamental things which are distinctively ours to use and to exploit.

We still send scholars to Oxford, but it is significant that Paul Engle produced on his scholarship time one of the most American volumes of recent verse. Europe has lost much of its magic. Gertrude Stein comes to us from Paris and is only a seven days' wonder. Ezra Pound's new volume seems all compounded of echoes from a lost world. The expatriates do not fit in with the newer America, so greatly changed from the old.

The Depression has also weakened the highly commercialized New York theater; and this fact, together with the wholesome development of little theaters, may bring us at last an American drama. For years our stage has been controlled by grasping New York producers. The young playwright or actor could not succeed unless he went to New York. For commercial reasons, it was impossible to give the drama any regional feeling; it had little that was basic to go on and was consequently dominated by translations or reworkings of French plays and by productions of English drawing-room comedies, often played by imported actors. The advent of the movies changed this condition only by creating another highly urbanized center at Hollywood. But we have now a revolt against this whole system—a revolt in which we have enlisted the community theaters, local playwriting contests, some active regional playwrights, and certain important university theaters.

Music (and perhaps I am getting out of my proper territory here, for I know little of music) seems to be doing less outside of the cities than letters, the theater, and art. One does note, however, local music festivals, as well as such promotion of community singing as that which Harry Barnhardt has led.

But painting has declared its independence from Europe, and is retreating from the cities to the more American village and country life. Paris is no longer the mecca of the American artist. The American public, which used to be interested solely in foreign and imitative work, has readily acquired a strong interest in the distinctly indigenous art of its own land; and our buyers of paintings and patrons of art have naturally and honestly fallen in with the movement away from Paris and the

American pseudo-Parisians. It all constitutes not so much a revolt against French technique as against the adoption of the French mental attitude and the use of French subject matter, which he can best interpret because he knows it best, an American way of looking at things, and a utilization of the materials of our own American scene.

This is no mere chauvinism. If it is patriotic, it is so because a feeling for one's own milieu and for the validity of one's own life and its surroundings is patriotic. Certainly I prefer to think of it, not in terms of sentiment at all, but rather as a commonsense utilization for art of native material and honest reliance by the artist upon subject matter which he can best interpret because he knows it best.

Because of this new emphasis upon native materials, the artist no longer finds it necessary to migrate even to New York, or to seek any great metropolis. No longer is it necessary for him to suffer the confusing cosmopolitanism, the noise, the too intimate gregariousness of the large city. True, he may travel, he may observe, he may study in various environments, in order to develop his personality and achieve backgrounds and a perspective; but this need be little more than incidental to an educative process that centers in his own home region.

The great central areas of America are coming to be evaluated more and more justly as the years pass. They are not a Hinterland for New York; they are not barbaric. Thomas Benton returned to make his home in the Middle West just the other day, saying, according to the newspapers, that he was coming to live again in the only region of the country which is not "provincial." John Cowyper Powys, bidding farewell to America recently in one of our great magazines after a long sojourn in this country, said of the Middle West: "This is the real America; this is—let us hope!—the America of the future; this is the region of what may, after all, prove to be, in Spenglerian phrase, the cradle of the next great human 'culture.'"

When Christopher Morley was out in Iowa last fall, he remarked on its freedom, permitting expansion "with space and relaxing conditions for work." Future artists, he wisely observed, "are more likely to come from the remoter areas, farther from the claims and distractions of an accelerating civilization."

So many of the leaders in the arts were born in small towns and on farms that in the comments and conversation of many who have gone East, there is today a noticeable homesickness for the scenes of their childhood. On a recent visit to New York, after seven continuous years in the Middle West, I found this

attitude very striking. Seven years ago my friends had sincerely pitied me for what they called my "exile" in Iowa. They then had a vision of my going back to an uninteresting region where I could have no contact with culture and no association with kindred spirits. But now, upon my return to the East, I found these same friends eager for news and information about the rich funds of creative material which this region holds.

I found, moreover, a determination on the part of some of the eastern artists to visit the Middle West for the purpose of obtaining such material. I feel that, in general, such a procedure would be as false as the old one of going to Europe for subject matter, or the later fashion of going to New England fishing villages or to Mexican cities or to the mountains of our Southwest for materials. I feel that whatever virtue this new movement has lies in the necessity the painter (and the writer, too) is under, to use material which is really a part of himself. However, many New York artists and writers are more familiar, through strong childhood impressions, with village and country life than with their adopted urban environment; and for them a back-to-the-village movement is entirely feasible and defensible. But a cult or a fad for midwestern materials is just what must be avoided. Regionalism has already suffered from a kind of cultism which is essentially false.

I think the alarming nature of the Depression and the general economic unrest have had much to do in producing this wistful nostalgia for the Midwest to which I have referred. This region has always stood as the great conservative section of the country. Now, during boom times, conservatism is a thing to be ridiculed, but under unsettled conditions it becomes a virtue. To the East, which is not in a position to produce its own food, the Middle West today looks a haven of security. This is, of course, the basis for the various projects for the return of urban populations to the land; but it is an economic condition not without implications for art. The talented youths who, in the expensive era of unlimited prosperity, were carried away on waves of enthusiasm for projects of various sorts, wanting nothing so much as to get away from the old things of home, now, when it all collapses, come back solidly to the good earth.

But those of us who have never deserted our own regions for long find them not so much havens of refuge as continuing friendly, homely environments.

As for my own region—the great farming section of the Middle West—I find it, quite contrary to the prevailing eastern impression, not a drab country inhabited by peasants, but a various, rich land abounding in painting material. It does not, however, furnish scenes of the picture-postcard type that one

too often finds in New Mexico or farther west, and sometimes in New England. Its material seems to me to be more sincere and honest, and to gain in depth by having to be hunted for. It is the result of analysis, and therefore is less obscured by "picturesque" surface quality. I find myself becoming rather bored by quaintness. I lose patience with the thinness of things viewed from outside, or from a height. Of course, my feeling for the genuineness of this Iowa scene is doubtless rooted in the fact that I was born here and have lived here most of my life. I shall not quarrel with the painter from New Mexico, from farther west, or from quaint New England, if he differs with me; for if he does so honestly, he doubtless has the same basic feeling for his material that I have for mine—he believes in its genuineness. After all, all I contend for is the sincere use of native material by the artist who has command of it.

Central and dominant in our midwestern scene is the farmer. The Depression, with its farm strikes and the heroic attempts of government to find solutions for agrarian difficulties, has emphasized for us all the fact that the farmer is basic in the economics of the country—and, further, that he is a human being. The farm strikes, strangely enough, caused little disturbance to the people of the Middle West who were not directly concerned in them; but they did cause both surprise and consternation in the East, far away, as it is, from the source of supplies. Indeed, the farm strikes did much to establish the midwestern farmer in the eastern estimation as a man, functioning as an individual capable of thinking and feeling, And not an oaf.

Midwestern farmers are not of peasant stock. There is much variety in their ancestry, of course; but the Iowa farmer as I know him is fully as American as Boston, and has the great advantage of being farther away from European influence. He knows little of life in crowded cities, and would find such intimacies uncomfortable; it is with difficulty that he reconciles himself even to village life. He is on a little unit of his own, where he develops an extraordinary independence. The economics, geography, and psychology of his situation have always accented his comparative isolation. The farmer's reactions must be toward weather, tools, beasts, and plants to a far greater extent than those of city dwellers, and toward other human beings far less: this makes him not an egoist by any means, but something quite different, a less socialized being than the average American. The term "rugged individualism" has been seized upon as a political catchword, but it suits the farmer's character very well.

Endnotes

Of course, the automobile and the radio have worked some change in the situation; but they have not altered the farmer's essential character in this generation, whatever they may do in the next. More important so far as change is concerned have been recent economic conditions, including the foreclosing of mortgages; and these factors, threatening the farmer's traditional position as a self-supporting individual, threatening even a reduction to a kind of American peasantry, brought on the violent uprisings of the farm strikes and other protests.

The farmer is not articulate. Self-expression through literature and art belong not to the set of relationships with which he is familiar (those with weather, tools, and growing things), but to more socialized systems. He is almost wholly preoccupied with his struggle against the elements, with the fundamental things of life, so that he has no time for Wertherism or for the subtleties of interpretation. Moreover, the farmers that I know (chiefly of New England stock) seems to me to have something of that old Anglo-Saxon reserve which made our ancient forebears to look upon much talk about oneself as a childish weakness. Finally, ridicule by city folks with European ideas of the farmer as a peasant or, as our American slang has it, a "hick," has caused a further withdrawal—a proud and disdainful answer to misunderstanding criticism.

But the very fact that the farmer is not himself vocal makes him the richest kind of material for the writer and the artist. He needs interpretation. Serious, sympathetic handling of farmer material offers a great field for the careful worker. The life of the farmer, engaged in a constant conflict with natural forces, is essentially dramatic. The drought of last summer provided innumerable episodes of the most gripping human interest. The nomadic movements of cattlemen in Wisconsin, in South Dakota, and in other states, the great dust storms, the floods following drought, the milk strikes, the violent protests against foreclosures, the struggles against dry-year pests, the sacrifices forced upon once prosperous families—all these elements and many more are colorful, significant, and intensely dramatic.

It is a conflict quite as exciting as that of the fisherman with the sea. I have been interested to find in the little town of Waubeek, near my home, farmer descendants of the folk of New England fishing villages. Waubeek has not changed or grown much since it was originally settled, because it was missed by the railroads and by the paved highways. The people of this community have kept as family heirlooms some of the old whaling harpoons, anchors, and so on which connect them with the struggle which their ancestors waged with the sea. But their

own energies are transferred to another contest, and their crops come not out of the water but out of the land. I feel that the drama and color of the old fishing villages have become hackneyed and relatively unprofitable, while little has been done, in painting at least, with the fine materials that are inherent in farming in the great region of the mid-American states.

My friend and fellow townsman Jay Sigmund devotes his leisure hours to the writing of verse celebrating the kind of human beings I have been discussing. He is as much at home in Waubeek—perhaps more so—as in the office of his insurance company. I wish to quote a poem of his in this place.

Visitor

I knew he held the tang of stack and mow—
One sensed that he was brother to the soil;
His palms were stained with signs of stable toil
And calloused by the handles of the plow.

Yet I felt bound to him by many ties:
I knew the countryside where he was born;
I'd seen its hillsides green with rows of corn,
And now I saw its meadows in his eyes.

For he had kept deep-rooted in the clay,
While I had chosen marketplace and street;
I knew the city's bricks would bruise his feet
And send him soon to go his plodding way.

But he had sought me out to grip my hand
And sit for one short hour by my chair.
Our talk was of the things that happen where
The souls of men have kinship with the land.

I asked him of the orchard and the grove,
About the bayou with its reedy shore,
About the gray one in the village store
Who used to doze beside a ruddy stove.

He told me how the creek had changed its bed,
And how his acres spread across the hill;
The hour wore on and he was talking still,
And I was hungry for the things he said.

Then I who long had pitied peasant folk

And broken faith with field and pasture ground
Felt dull and leaden-footed in my round,
And strangely like a cart-beast with a yoke!

There is, of course, no ownership in artistic subject matter except that which is validated by the artist's own complete apprehension and understanding of the materials. By virtue of such validation, however, the farm and village matter of a given region would seem peculiarly to belong to its own regional painters. This brings up the whole of the ancient moot question of regionalism in literature and in art.

Occasionally I have been accused of being a flag-waver for my own part of the country. I do believe in the Middle West—in its people and its art, and in the future of both—and this with no derogation to other sections. I believe in the Middle West in spite of abundant knowledge of its faults. Your true regionalist is not a mere eulogist; he may even be a severe critic. I believe in the regional movement in art and letters (comparatively new in the former though old enough in the latter); but I wish to place no narrow interpretation on such regionalism. There is, or at least there need be, no geography of the art mind or of artistic talent or appreciation. But painting and sculpture do not raise up a public as easily as literature, and not until the breakup caused by the Great Depression has there really been an opportunity to demonstrate the artistic potentialities of what some of our eastern city friends call "the provinces."

Let me try to state the basic idea of the regional movement. Each section has a personality of its own, in physiography, industry, psychology. Thinking painters and writers who have passed their formative years in these regions will, by caretaking analysis, work out and interpret in their productions these varying personalities. When the different regions develop characteristics of their own, they will come into competition with each other; and out of this competition a rich American culture will grow. It was in some such manner that Gothic architecture grew out of competition between different French towns as to which could build the largest and finest cathedrals. And indeed the French government has sponsored a somewhat similar kind of competition ever since Napoleon's time.

The germ of such a system for the United States is to be found in the artwork recently conducted under the PWA. This was set up by geographical divisions, and it produced remarkable results in the brief space of time in which it was in operation. I should like to see such encouragement to artwork continued and expanded. The federal government should establish regional

schools for art instruction to specially gifted students in connection with universities or other centers of culture in various sections.

In suggesting that these schools should be allied with the universities, I do not mean to commit them to pedantic or even strictly academic requirements. But I do believe that the general liberal arts culture is highly desirable in a painter's training. The artist must know more today than he had to know in former years. My own art students, for example, get a general course in natural science—not with any idea of their specializing in biology or physics, but because they need to know what is going on in the modern world. The main thing is to teach the students how to think. And, if they can, to feel. Technical expression, though important, is secondary; it will follow in due time, according to the needs of each student. Because of this necessity of training in the liberal arts, the government art schools should be placed at educational centers.

The annual exhibits of the work of schools of this character would arouse general interest and greatly enlarge our American art public. A local pride would be excited that might rival that which even hardheaded businessmen feel for home football teams and such enterprises. There is nothing ridiculous about such support; it would be only a by-product of a form of public art education which, when extended over a long period of time, would make us a great art-loving nation.

Mural painting is obviously well adapted to government projects, and it is also highly suitable for regional expression. It enables students to work in groups, to develop original ideas under proper guidance, and to work with a very definite purpose. I am far from commending all the painting that has gone onto walls in the past year or two, for I realize there has not been much success in finding a style well suited to the steel-construction building; but these things will come, and there is sure to be a wonderful development in mural painting within the next few years. In it I hope that art students working with government aid may play a large part. My students at the State University of Iowa hope to decorate the entire university theater, when the building is finished, in true fresco; and there is to be regional competition for the murals and sculpture in three new Iowa post offices—at Dubuque, Ames, and Independence.

I am willing to go so far as to say that I believe the hope of a native American art lies in the development of regional art centers and the competition between them. It seems the one way to the building up of an honestly art-conscious America.

It should not be forgotten that regional literature also might well be encouraged by government aid. Such "little" magazines

as Iowa's *Midland* (now unfortunately, suspended), Nebraska's *Prairie Schooner*, Oklahoma's *Space*, Montana's *Frontier* might well be subsidized so that they could pay their contributors. A board could be set up which could erect standards and allocate subsidies which would go far toward counteracting the highly commercialized tendencies of the great eastern magazines.

But whatever may be the future course of regional competitions, the fact of the revolt against the city is undeniable. Perhaps but few would concur with Thomas Jefferson's characterization of cities as "ulcers on the body politic"; but, for the moment at least, much of their lure is gone. Is this only a passing phase of abnormal times? Having at heart a deep desire for a widely diffused love for art among our whole people, I can only hope that the next few years may see a growth of nonurban and regional activity in the arts and letters.

79. Corn, *Grant Wood*, p. 88. "Whereas she is old-fashioned and set in her ways, the dial phone—whose long-neck parodies hers—is the most progressive instrument of the day. She is reserved and repressed, but the phone is perky and alive, stretching like a daffodil to the sun, inviting someone to pick it up and talk into its mouthpiece. There is no way, the artist suggests, for the prim Victorian world of the woman, closed to outsiders and expressions of emotion, to adjust to the jangling, intrusive world of the telephone. They are creatures from two completely different social systems; the phone is the victor, Aunt Tillie the victim."

80. Hazel E. Brown, *Grant Wood and Marvin Cone: Artists of an Era* (Ames: Iowa State University Press, 1972).

81. James Johnson Sweeny, "Grant Wood," *New Republic* 8 (May 29, 1935), p. 76ff.

82. Matthew Baigell, *The American Scene: American Paintings of the 1930s* (New York: Praeger, 1974).

83. Dennis, *Grant Wood*, p. 38.

84. Corn, *Grant Wood*.

85. Corn, p. 133, interprets the pitchfork as a phallic symbol, and calls the "reflection" of the implement in McKeeby's overalls as a reference to his fading masculinity. I believe that that "reflection" is an affectionate one referring to the shining breast-

plate in Hans Memling's *Adoration of the Virgin.* "The pitchfork, clutched in his hand, becomes much more than an emblem of rural living and hard work; it is also a symbol of male sexuality and paternal authority. The father interposes the cold, steely tines of his fork between us and his daughter, warning any who might entertain thoughts of trespass—against daughter or homestead. But lest we take the old man's bravura too seriously, the artist parodies his virile show of aggression by mirroring the phallic pitchfork in the scams of his overalls, where the three-tined shape appears limp and worn with age.

86. Hughes, *American Visions*, pp. 194ff.

87. Seery, *America Goes to College.* Seery also gets hung up on the window that started it all:

The Gothic window situated between the heads of the two figures in American Gothic invites a comparison to the mirror that Foucault analyzed in Velázquez's *Las Meninas.* Wood's window is of course a window on liberalism, that observance of a distinction between public matters and private spheres. It is a window that formally holds the couple together, a window that is presented to our public eye; but in the painting, it is covered from inside, so that we cannot peer any farther inward. An apron-pattern curtain shields our eye; we are no longer looking through stained glass as in other Gothic windows, toward some colorful, ecclesiastical, other world. For Foucault, the mirror in *Las Meninas* engenders a fascinating movement of ricocheting gazes between invisible painter and invisible spectator. The sovereign, albeit invisible, gaze of the absent painter imposes order on its diverse publics; it cleverly constructs and organizes a universalized subjectivity by purportedly mirroring a common absence. *American Gothic*, too, plays with similar framing devices of exchanged stares, windows within windows, the staging of stagings, and posed poses, thus the offstage spectator tends to inquire after the absent painter, who presumably once occupied the same frontally scrutinizing position. Yet I want to suggest that Wood is not trying to discipline us into a new spectatorial regime, and this demurral or forbearance is the key to his irony. Irony, in this context, could be defined as a disruption of the sovereign gaze, a choral parabiosis, a knowing pause in the transfer of imaginary feints and glances. The ironic artist cedes some ocular control by calling attention, through winks and puns, to his mock inscrutability; so goaded, we no longer can stand there spellbound. True, we, the American viewing public(s), have characteristically looked to *American*

Gothic hoping to find a mirror, hoping to team something, to see something reflected about ourselves, a common and stable American subjectivity or narrative, a solvent identity or destiny. We have, in other words, internalized the family photo album experience. But Wood does not play it straight. We cannot take the painting completely seriously, which may be the reason it continues to recur periodically in pop fashion. It lives on. Indeed, the central irony of this gag-piece painting may be that it somehow lives on and retains interest, accommodating over many decades a running succession of stabilizations, subversions, and cover-ups, and back again. That ironic movement turns, I propose, on the covert suspicion that if this painting is about concealed family dysfunction or spinsterdom in some whispered way, then this couple is one contemplating a childless future—wifeless Lot's gaze is now grim—yet we latter-day Americans are somehow still implicated, are somehow nonetheless the children of Lot, the legatees of this sometimes sinful, sometimes virtuous biblical story. The painting is surely about American ancestors and their possible failings, their bleak futures, and yet we spectators also stand in living contradiction, partial mockery, to that narrative. History, generationalism, or survival—what Stanley Cavell might call Emersonian perfectionism—in America is never simply continuous but occurs in fits and starts; pioneering breaks from the past hardly ever deliver redemption, renegotiated beginnings in their stead open futures that are far from certain. Grant Wood's distant affection is to remind us that we are still here, as sympathetic and inquiring observers, that we have not yet succumbed to dark forces in our collective past. Irony, I have argued elsewhere, often is invoked by Orphic artists as a creative response to death—and, after all, *American Gothic* was painted over a mortuary garage.

BIOGRAPHY OF
THOMAS HOVING

1931: January 15: Born Thomas P. F. Hoving in New
 York City. Mother, Mary Osgood Field; father,
 Walter Hoving, retailing whiz kid who even-
 tually bought Tiffany & Co.

1931–1938: Resided in Lake Forest, Illinois. Attended the
 Bell School.

1938: Following parents' divorce, moved to New
 York City to live with mother. Attended the
 Buckley School until 1940.

1939–1947: Attended the Eaglebrook School, Deerfield,
 Massachusetts. Excelled in arts, general stud-
 ies, and sports.

1947–1948: Attended Exeter Academy, New Hampshire. Invented the modern short Lacrosse goalie's stick.

1948–1949: Attended the Hotchkiss School, Connecticut. Graduated summa cum laude.

1949–1953: Attended Princeton University, majoring in art and archaeology. Graduated summa cum laude.

1953: Married Nancy Melissa Bell of New York City, whom he met in 1951 while at Princeton. Nancy's father, Elliott V. Bell, was Thomas Dewey's campaign manager in 1948, and launched *Business Week* magazine. One daughter, Trea, born in 1957. Three granddaughters, Amelia, Kate, and Matilda.

1953: Enlisted in the Marine Corp. during Korean War. Promoted to 1st lieutenant.

1955–1959: Attended Princeton University graduate school in art and archaeology on a Kienbusch-Haring Fellowship.

1956–1957: Left school for Europe, to see works of art in person rather than in photographs. Lived in Rome, traveling around Italy, France, Austria, Hungary, Germany, and Holland looking at art. Learned four languages. Member of the staff at excavations in Sicily at Morgantina, an ancient Greek site, in 1957.

1958: Returned to Princeton University. Awarded master's of fine arts degree.

1959: Awarded Ph.D. in art history; thesis on Carolingian ivories.

1959: Hired by the Metropolitan Museum of Art in the Medieval Department and the Cloisters.

1960: Put in charge of all acquisitions in the two departments.

1960–1965: Collected a host of medieval works, including the Bury St. Edmunds cross, an English ivory dating to 1156, called the greatest English work ever created during the Middle Ages.

1965: Left the Metropolitan Museum to serve as parks and recreation researcher in John Lindsay's mayoral campaign and wrote the white paper on the subject.

1966–1967: Appointed commissioner, then administrator, of Parks and Recreation, in New York City. Credited with the idea of closing great parks off to traffic.

April 1, 1967: Named seventh director of the Metropolitan Museum of Art. Responsible for a massive building program that added 125 galleries to the museum and doubled its space. Directed extensive acquisitions, including the Lehman

Collection, the Packard Collection, Diego Velázquez's *Juan de Pareja*, Monet's *Terrace at Sainte Adresse*, the *Euphronios* vase of 510 B.C., and the Temple of Dendur. Also organized and chose works for the King Tut show of 1976–1979. Is credited with bringing the museum into the modern world and significantly popularizing it.

1977: Left the Metropolitan Museum.

1977: Named on-air correspondent and arts and entertainment editor for ABC's *20/20*. Created entertainment pieces on the stolen Getty bronze, Dolly Parton, Conway Twitty. Left in 1985.

1978: Wrote first book, *Tutankamun: The Untold Story*, published by Simon & Schuster. Landed on New York Times best-seller list.

1979: Started Hoving Associates, a museum consulting firm, with wife, Nancy. Clients included the Egyptian government, the Houston Museum, and Henson Associates.

1980–2005: Wrote twenty-two more books, including *False Impressions: The Hunt for Big-Time Art Fakes* and *Art for Dummies*.

1985: Awarded private pilot's license and subsequent commercial rating. Flies own plane.

1986–1992: Editor-in-chief of *Connoisseur* magazine. Wrote
 numerous articles and a monthly column. Ex-
 posed curatorial corruption at the Getty
 Museum; exposed Getty's famous sixth-
 century B.C. Greek kouros as a fake.

 American Gothic and Master Pieces, the
 quintessential curators' art game, published in
 2005.

 Awards: Numerous—three honorary degrees,
 including a doctor of Humane Letters from
 Princeton; honorary member, the American
 Institute of Architects; "Least Likely to
 Succeed," as cited in the Hotchkiss yearbook;
 and Client of the Year from the New York Bar
 Association, for the many lawsuits lodged
 against the Metropolitan during his tenure.